FINGER PAINTING WEEKEND WORKSHOP

A Beginner's Guide to Creating Brush-Free Works of Art | IRIS SCOTT

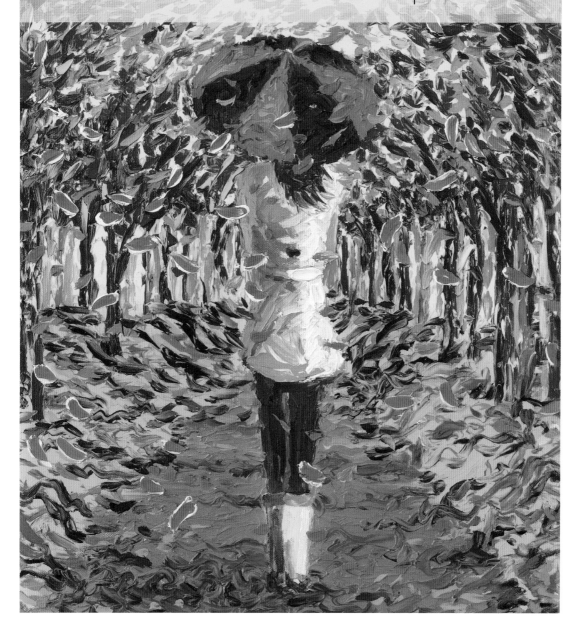

Race Point
PUBLISHING

Quarto is the authority on a wide range of topics.

Quarto educates, entertains and enriches the lives of our readers—enthusiasts and lovers of hands-on living.

www.quartoknows.com

First published in the United States of America in 2016 by
Race Point Publishing, a member of
Quarto Publishing Group USA Inc.
142 West 36th Street, 4th Floor
New York, New York 10018
quartoknows.com

Visit our blogs at quartoknows.com

10 9 8 7 6 5 4 3 2 1

ISBN 978-1-63106-143-1

Library of Congress Cataloging-in-Publication Data is available

Author: Iris Scott
Editorial Director: Jeannine Dillon
Managing Editor: Erin Canning
Project Editor: Jason Chappell
Senior Design Manager: Heidi North
Interior Design: Leah Lococo
Production Design: Bob O'Brien Design
Cover Design: Leah Lococo

Printed in China

To Barbara Quirie,

my first grade teacher, an artist herself

who taught us how to save all of our painting mistakes like pros.

Acknowledgments

I would like to express my deep gratitude to my editor, Jeannine Dillon of Quarto Publishing Group, for pitching this book and making the idea a reality. Very special thank yous to writer Jackie Bondanza for her help translating my workshops into a cohesive book, and to photographer Rick Schwab for capturing these lessons with his crystal clear Nikon®. I also want to thank my mentor, Michael Smith, for his guidance, his "think big" mentality, and his business sense. Deep gratitude goes out to my mommy and daddy, Celia Cazzato and John Scott, for just being fabulously artistic parents. And a loving thank you to my sister, Nina, for being crazy cool.

I would also like to extend my thanks to the art teachers I had throughout my schooling in the Tahoma school district: Ms. Mjelde, Mr. Brooks, Mr. Sims, and Ms. Gardner.

Finally, I wish to thank my friends and fans on Facebook, for not only consistent and thoughtful feedback, but for your ever-encouraging comments, likes, and shares that have kept me motivated to keep practicing finger painting.

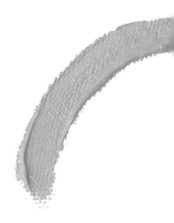

CONTENTS

19

45

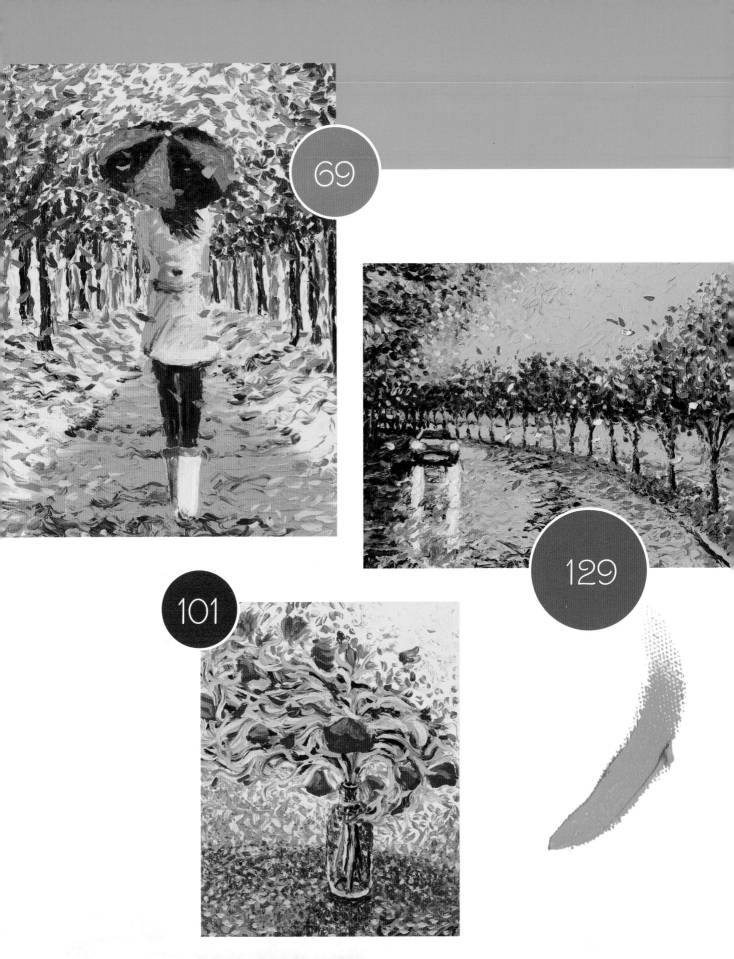

69

129

101

INTRODUCTION

It is easy to reconnect with your inner child when finger painting. No matter your artistic background it is a fun way to create something beautiful. All you need before embarking on your first oil finger painting is a love for thick oil texture and bright colors. I've spent years teaching beginners how to leave their stress at my door when they attend my workshops. The lessons within *Finger Painting Weekend Workshop* are designed to simplify and demystify the artistic process so that anybody, whether a beginner or an expert, can pick it up.

One of the best things about finger painting with oils is that anyone can do it. But there are tons of other benefits to skipping the brushes:

1. You don't have to lose time doing the boring brush-cleaning step. Finger painting is much faster than brushes!
2. You don't need to use smelly solvents or thinners to clean your brushes. Just two seconds with a paper towel does everything to clean your gloves!
3. You can FEEL your paints—literally—because you're not separated by a brush on the end of a long stick. You're closer to your art!
4. Finger painting as an adult is therapeutic. Add it to your yearly entertainment budget. You only live once!

Who says painting has to be done with brushes? I'd argue that if surgical gloves had been invented a hundred years earlier, fine-art finger painting would have gone mainstream years ago. I receive messages every day from new finger painters the world over that are delighted with this crazy new medium. I've met adults that have used finger painting to cope with trauma, including the loss of loved ones. There are therapeutic qualities to

touching a rainbow of colors. Finger painting is like cake frosting but sugar-free, and the colors have way more punch and lasting beauty.

Now bear in mind that there is no single way to paint with fingertips. I discovered finger painting accidentally in 2010, after a bout of laziness around cleaning my brushes lead me to experimenting with my fingers. I was so astounded by the ease with which I could fly through different colors that I took up finger painting full time. Since then I've learned from my experiences and will share tips and tricks to help you create a painting you can be proud of.

Before we get started I want to talk about start-up costs. Please give yourself permission to buy the good oil colors. Quality paint makes a huge difference in the end results. I use Holbein Duo Aqua Oils because they can wash off surfaces with water and their colors are the brightest in the industry. If you already have your own oils, you can mix them with these; however once combined with regular oils, the Holbein oils lose the ability to wash away. Also if you choose not to buy the specific colors I suggest, do your absolute best to color-match before getting started.

Why not take a day off to finger paint this weekend? You can spruce up your home décor with a painting or give a beautiful handmade gift to a friend. Finger painting has been claimed by kindergarteners for too long; it's time for adults to reclaim the magic—and fun—of this amazing technique. Give your brushes a rest and join the finger-painting revolution!

Artfully yours,
Iris Scott

GETTING STARTED

Many people ask me how finger painting is different from brush painting and why it's so wonderful. Brushes are hard to clean because they have so large a surface area. Is it easier to wipe paint out of a shag carpet or off of linoleum? The same principle applies to finger painting. We gain so much by working with one point of contact—i.e., your fingertip(s)—that's fast to clean because we can switch between colors without as much muddiness. With finger painting, we also don't need to use water or solvents or soap to clean all those bristles. Moreover, unlike a paintbrush your fingertips have tiny nerve endings, so I find that I can really feel the paint!

Materials

Why Use Oils?

Finger painting also invites you to let go and let the paint do the work for you. Please don't paint thinly because that's just not what finger painting is best at. Save that for brushes. Watercolors, for instance, are great for transparent washes, but you wouldn't use them to paint thick, right? Could you paint thickly with watercolors? Of course! But why bother when other mediums are so much more effective? The more oil paint you put on the canvas the less you'll have to work at achieving a richly vibrant effect, because the accidental swirls that occur when wet oils hits wet thick oil is our game!

Another advantage of finger painting, as we've said, is that it enables you to clean your fingers very fast. Have a little extra paint on your fingertips but you're ready to move on to another color? Just wipe the excess on the side of the canvas or on a paper plate for later, and take a paper towel to your hands. It's as easy as that: two to three seconds of cleaning time. Finger painting wastes less paint, and saves money!

Can you finger paint with other mediums? Yes, you can use acrylics too, but they're just not as forgiving as oils. Acrylics dry too fast — sometimes in just an hour. You can't get the texture and richness from any other medium. If you want your oil painting to look masterful and impressionistic, splurge on the good stuff; you deserve to paint with oils—they're the best, plain and simple.

Why Wear Gloves?

Do not finger paint with bare hands under any circumstances! The paint we use is not skin-safe. Nitrile or latex gloves are best for our purposes, and make sure to wear ones with a tight fit. They shouldn't be baggy, but don't let them cut off circulation! I use powder-free Kimberly Clark Purple Nitrile gloves in size small that I can easily find on Amazon. You can also ask your dentist or doctor for a few free pairs! One pair of gloves can easily last several paintings; they're quite durable. As long as you wipe them down really well with your paper towel, it's possible to use them for several paintings.

Do I Need an Easel?

You do not NEED an easel. It's merely a luxury. But for fifteen dollars, it's a luxury that is well worth it! The easel allows you to view your painting from across the room and removes that hunched-over posture required when painting on a tabletop.

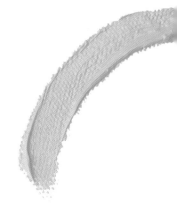

Using a 16 x 20-inch (41 x 51 cm) Canvas (or Smaller)

I've certainly learned the hard way that smaller is better in the beginning, when learning to finger paint thick with oils. The reason for this is that paint gets sticky and starts ripping when it begins to dry. As a rule of thumb, I finish my paintings the same day I start them, and that's what gives them that watery,

painterly look of wet-into-wet oil paint. A 16 x 20-inch (41 x 51 cm) canvas is literally a perfect size commitment. This is a one-day painting size for a beginner. If you want to go bigger, please extend your painting with additional panels; otherwise you truly risk the icky look of partially dried oil paint underneath new paint. Yuck!

Important Concepts

Why It's Important to Complete in One Sitting

It's important to finish a painting in one day because it will keep that painting loose and fluid. That fluid look, in fact, is sort of our "cheat" to a painterly effect. I highly recommend finishing your painting in 6–8 hours. Can you continue to paint over the course of many days, weeks, or months? Yes, but I don't, and it has worked really well. PLEASE experiment down the road, but in the beginning, as you follow this workshop course, try "my way" so you can learn the rules, and then go break them as you wish.

Stepping Back and Taking a Break

"Fresh Eyes" is the name of the game. I use an arsenal of strategies to get fresh perspective on my painting before it dries. Here are a few good strategies:

1. Ask a friend! Take snapshots with your phone and text it to buddies as you go. Listen to them! They have a fresh perspective.
2. Take snapshots every 15 minutes so that you can see if you are over-touching your painting.
3. Look at your painting with a mirror—a little handheld mirror works perfectly. This flips the painting and gives a fresh perspective.
4. Work alongside a friend, take breaks, or walk around the block and come

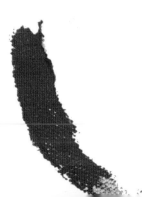

back in 30 minutes. You'll be amazed by how quickly you realize what's missing, or what needs to be added.

5. Set up your painting and then walk to the other side of the room to get a long-distance view of your artwork.

Understanding the Colors

Some colors are stronger than others and overpower them, and some need to be applied to the canvas in layers to make them stand out. When I use white, for instance, I save it for last or I don't use it at all, because white loves to ruin paintings. It turns colors into mud, so if you must use it for highlighting and clouds, please wait until the end and save yourself frustration. Also, never ever buy black paint—it's a truly useless color! Instead, use Dioxazine Purple, or Prussian Blue, or better yet, mix your darkest colors together. You'll achieve a richer, more realistic "black" when you do this.

Understanding the Paint

I use a specific type of paint—Holbein Duo Aqua oils—for many different reasons, but mostly for the richness of color and texture that it provides. Inexpensive paint equals dull colors and makes ugly colors when mixed together, setting yourself up to fail! Paint companies vary dramatically, and if you opt for the cheaper student-grade oils you will be somewhat swimming upstream. You only live once, and think how easy it is to spend a couple of hundred dollars on junk food. Do yourself a favor and splurge on this paint—this is an investment in art therapy, home décor, creativity, and entertainment. You get what you pay for with paint, so make your painting experience more fabulous by investing in the good stuff. You are worth it!

While you can use other oils, I'd highly recommend Holbein Duo Aqua oils, for the following reasons:

1. They have the brightest, most vibrant colors money can buy.

2. They're really consistent tube to tube, so you never get a hard paint trying to mix with a soft paint.

3. They wash up with water! Yep, they're oils and they can even be mixed with your grandmother's old box of oils. But if you don't mix them with other brands, you have the luxury of skipping smelly solvents and using just soap and water to clean up. For the most part, the paint will come out of clothes and wipe off surfaces with limited effort. Be careful with the dark colors, such as Phthalo Green, however; some colors like to stain.

Making Things Look Natural

Lines are made of dots. If you want to draw a tree trunk, for example, think in terms of successive dots rather than one big fat line. We want to keep things abstract, impressionistic, and natural with all five of these paintings. When painted a little blurry, the world will actually appear more realistic; trust me. Hard edges are not good. Blur the boundaries between the edge of a car and the road. Blur the edges between road and sidewalk, etc.

Moving Colors into Colors to Create More . . . Colors

You may find yourself making lots of mistakes as you work through these projects but I don't want you to worry—so many of the mistakes are easy to fix. The great part of finger painting is that your fingers are a built-in eraser! If you make a line that's too thick, for instance, just clean your fingertip and push the surrounding colors into the oversized line. It's amazing what easy fixes like these will achieve. We will go through more specific mistakes and easy-to-follow fixes in each project.

Cleaning Those Gloves!

One pair of latex gloves should easily last you an entire painting, if not two entire paintings. If your hands get sweaty or you need to answer a phone call, be sure to rub all the paint off your gloves very thoroughly with a clean paper towel before taking the gloves off. Turn the gloves inside out when you pull them off. It's best to let them air-dry for a few minutes if they're sweaty, and don't try to put them back on if your hands are wet or still sweaty because they will stick in the most frustrating way possible. To put them back on, stuff the fingers into the wrist and then blow on it like a balloon. Wait a few minutes to let the breathy moisture escape the glove, then put it on again . . . and get back to work.

Squinting Your Eyes

It's human nature to fixate on one area or focus on a single part of an image. But sometimes this leads to not seeing the forest for the trees. If you feel yourself getting a little stuck on a spot and are not sure what to do, try squinting your eyes until you can barely see your painting. There's a good chance that when you only see the general shapes and colors you'll be more attuned to whether that little detail is even a problem at all. Squinting your eyes is just another one of the many strategies to get a fresh perspective.

Painting the Canvas Sides for Framing

It takes only a few minutes to paint the edges of each painting, which makes the painting appear to wrap around the sides. The effect is gorgeous, and all the galleries I've dealt with have asked for it. Framing looks great, too, and if you want to spend that extra money, by all means do. I also recommend adding a wire to the back to make hanging an option.

Drying Time

Here's a breakdown of how dry your painting is at different points and how long you should let it dry for different stages, depending on what you plan to do with it.

10 hours — This is when the paint gets a little icky to paint with, which is why I recommend completing within 6 hours.

2 Weeks — At the 2-week mark you can pick up the canvas without getting paint all over your hands.

4 Weeks — Wait at least 4 weeks before you package and ship a canvas, frame the canvas, or are rough with the canvas.

4 Months — Wait at least 4 months before varnishing your canvas (an optional step that can help seal the painting from dust, making clean-up slightly easier).

Storing Your Painting

Setting the picture on a piece of newspaper is a smart way to store your painting without getting paint on the furniture. I imagine you have quite a bit of oil paint left; good oil paint too! I'd recommend you play with it, attempt a small finger painting, or better still, get out some brushes and give them a test spin. Oil paint is a magical substance and every adult deserves to play with it. Stop worrying about the cost—you are worth every penny of this therapeutic and colorful pastime!

Extending Paintings to a Larger Canvas

I think an artist's biggest threat to their long-term success is biting off more than they can chew. If you want to paint larger, first try extending the scene by a canvas or two. This way you won't get overwhelmed with a

larger canvas, and each piece is successful on its own. It's also fun to mix and match and to extend the narrative of a painting without inhibiting previous ones.

Selling Your Work

Finger painting achieves a luscious effect, and it's no secret that the easiest types of paintings to sell are thickly painted oil landscapes. I haven't made up this fact—I hear it over and over from galleries. If you're comfortable with parting ways with your painting, do yourself a big favor and first take a high-definition picture of your artwork. Use a tripod if you have one, and a manual focus function, and shoot your painting outside in the shade (direct sunlight is rarely a good idea).

Keep the original image file in a very safe place for your personal archive, and then resize a second version to 1,500 pixels (wide or tall) for the Internet. It's important that you don't release the full image file to the Internet because people can easily download and print it. Make a Facebook or Instagram page and post the painting as FOR SALE. Don't add a price just yet—let interested parties inquire. Negotiate a price privately, and then when you've made the sale—it's not final until you have the money and the shipping fees—that's when you can in all caps announce "SOLD!" Facebookers love to watch you succeed, and they'll be eager to see your new artworks sell as well. Pour your earnings back into your materials and keep upgrading your colors. If you get too attached to what you've already made, you might not grow and improve as quickly as an artist who is eagerly focusing on what they can achieve versus what they've already achieved.

TECHNIQUES

Here are some of the more common techniques used throughout the book for different strokes, paint amounts, and movements on the canvas. Although this book is for beginners who have never painted before, feel free to practice these strokes on a separate blank canvas if you feel you need some warming up before beginning a project.

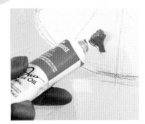

Chickpea-sized amount of paint

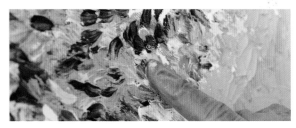

Pea-sized amount of paint

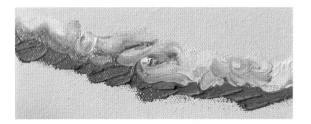

Circular, squiggling motion

Dot

Dab

Line, squiggly

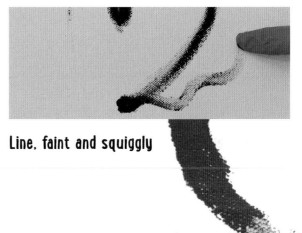

Line, faint and squiggly

Stroke

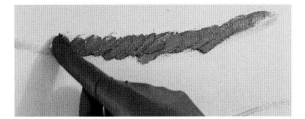

Stroke, short and chunky

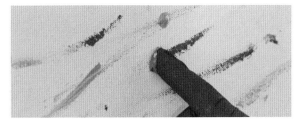

Stroke, short and wispy

Stroke, arch-like stroke

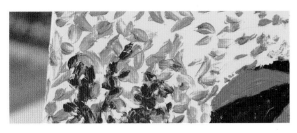

V-shape

Trailing off

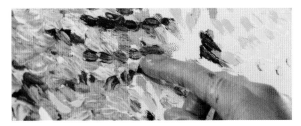

Z Pattern, loose (abstract)

Z Pattern, squished (tight)

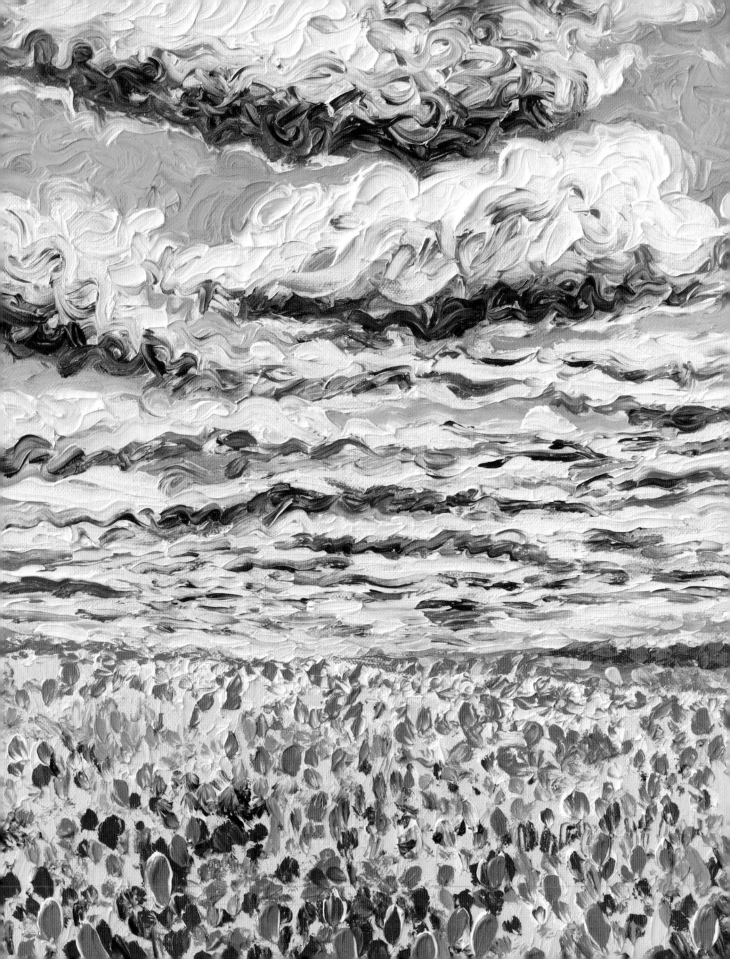

CLOUDS

Clouds are finger painting–friendly because they're already quite nondescript, which makes them forgiving—and an excellent place to start. Van Gogh was a master of painting textural cloudscapes. Give yourself permission to cake on the oil for this painting, like he did, especially the fluffy white muffin tops. This cloudy scene reminds me of the tulip farms in Washington state. I chose an orange flower farm for this piece, but change it up once you're comfortable by using your favorite tulip or poppy color, such as red, pink, or yellow.

Your stroke sizes should get smaller and smaller as they near the horizon line. And cover up that canvas! We don't want any blank canvas showing through, even specks. Texture is the name of the game, so be copious with that paint; you won't regret it by the time we are finished. Don't forget to continually clean your paint-stained fingertips whenever they're contaminated with colors you don't want and be generous with the paint. Let's get started!

MATERIALS

What You'll Need:

latex gloves; 16 x 20-inch (41 x 51cm) canvas; roll of paper towels; easel

10 oil colors:

Naphthol Red, Luminous Orange, Titanium White, Luminous Opera, Lavender, Lemon Yellow, Luminous Violet, Phthalo Green, Cobalt Blue Hue, Horizon Blue

▲ Set up your canvas horizontally on your easel and place the roll of paper towels close by. Put on your gloves and remove all the paint caps.

Paint the Horizon Line and Cloud Outlines

1 Pick up Horizon Blue. Place a chickpea-sized amount of paint on the tip of your pointer finger and place your finger one-third of the way up from the bottom of the canvas on the left side. Don't go more than a third because we don't want to split the landscape and the sky directly in half; it's unrealistic.

2 With your finger, draw a blue line from the left of the canvas about one-quarter of the way in, dipping down a bit to give the landscape a valley. End on the opposite side of the painting a bit higher than where it started to give it a slight peak. You may need to add more paint to your finger as you go. It doesn't have to be a solid blue line.

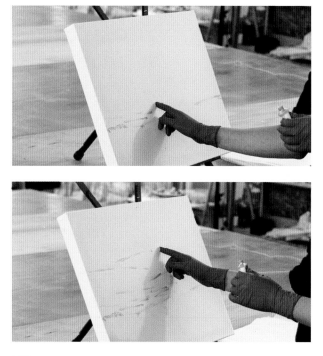

3 Now, the key to painting great clouds is squished Z patterns! Reload Horizon Blue on your pointer finger and, beginning with the left side of the canvas, paint a tight zigzag pattern focusing on the left side of the canvas. Keeping tight to the land, make the pattern wider and further apart as you move up to the top of the canvas. Reload your finger with paint as needed.

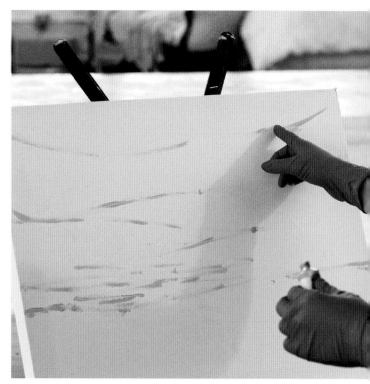

4 As you get to the upper part of the canvas, the zigzag pattern should become looser, because these clouds are higher in the sky. At the top-right and -left edges of the canvas, swoop the edge of the stroke up into the top corners (instead of having them come right from the edges in a straight line, like the zigzag pattern in Step 3).

Create the Clouds' Underbellies

1 Clean your fingers and pick up Lavender. Place a pea-sized amount on your fingertip. We are going to create the underbellies of the clouds now and I need you to be gluttonous with this paint to get the texture. Starting with the upper-left side of the canvas (on just the left blue line), make small, short, chunky strokes above the blue zigzag lines of the cloud. We want those big puffy clouds in the upper half of the sky because they're in the distance. Texture is your friend here. Painting with a lot of paint here sets us up to succeed later, whereas being skimpy on paint will make it more difficult later in the painting.

2 Continue with the strokes on the second layer of blue zigzag lines but don't be as exact about the strokes; as you move down toward the bottom of the canvas, the lavender strokes should become more undefined and less definite. Reload paint on your finger as needed, wiping your fingers clean after you merge the Lavender with the Blue.

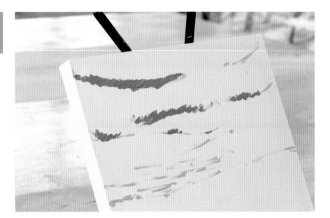

3 Add a few strokes to the third layer of blue zigzag lines, covering even less of the blue line than you did in the second row.

4 On the bottom half of the sky, create small wispy strokes with the Lavender, about a finger's width above a couple of the blue lines. These should trail off and not be too chunky.

5 Here's what your painting should generally look like at this point. Do your best to copy me pretty closely at this stage. Later, toward the end of your painting, is when you should try experimenting with your own "look," if you so choose.

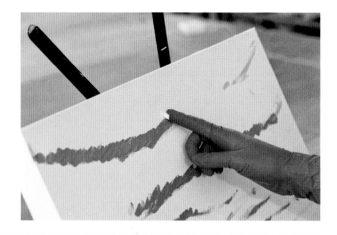

6 Clean your fingers and pick up Titanium White. Place a pea-sized amount on your pointer fingertip and run it along the top-left cloud line, right above the purple. (Remember: you achieve much more control with the tips of your fingers as opposed to the pads.) It should be one long line, colliding with the purple. This will activate the purple paint. Color collisions are your friend.

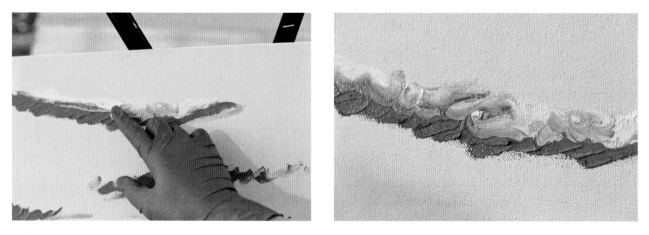

7 Using your pointer finger, make a circular, squiggling motion along the purple and white border to blend the purple and the White at the edges. Shoot for swirls, but don't-over touch the canvas. Less is more!

Fill in the Top Parts of Clouds

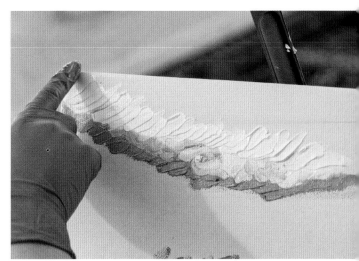

1 Clean your fingers and reload your fingertip with Titanium White. We're going to fill in the top part of the cloud now. (We want the clouds in the upper third to have a puffy muffin-top pattern; the clouds in the lower third will have more of a tight zigzag pattern.) Apply short, chunky strokes of White above the blended edge you just made, following the angle of the paint (a slight angle moving up into the left corner of the canvas). You will need to reload paint a few times. Go right up to the upper-left edge of the canvas.

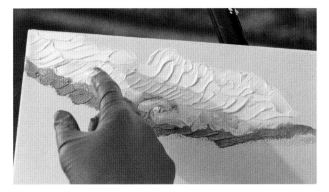

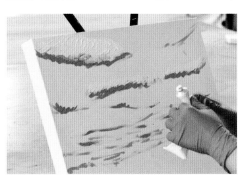

2 Apply another layer of chunky white strokes on top of the existing ones, but now use wave patterns. Move from top to bottom on a slight angle and paint an "S" shape to create a wave effect. This will give this row a slightly different texture. Be generous with the White; no scrimping!

3 Now let's move down to the second layer of clouds. We are going to apply the White above the purple lines on this layer in more of a zigzag motion. You can apply the White directly from the tube onto the canvas or you can use your finger. Squeezing paint onto a palette or paper plate is really not a useful step. In fact, I would encourage you not to use a palette at all. What blasphemy!

4 Take the White and apply arch-like strokes to the tops of the clouds in the second layer. Apply several on the top of each cloud (the tops are right underneath the bottom blue lines of the clouds of the top layer). Work in a lighter feather touch if it seems like the paint isn't going down.

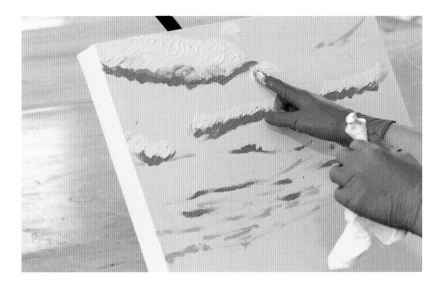

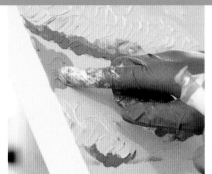
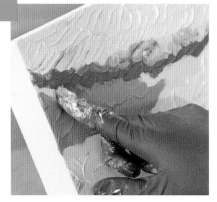
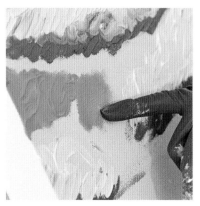

1 Clean your fingers. Pick up Horizon Blue. Place a chickpea-sized amount on your pointer finger and, starting with the upper-left side of the canvas under the Lavender of the top-left cloud, apply the Horizon Blue in a half-circle motion, being generous, to fill in the space between the two clouds. Go right up to the Lavender, being careful not to blend the two colors too much. Reload the paint as needed.

2 Be careful not to rub in the Blue too much, you want it to be chunky and have texture. If you rub it in too much, as I've done here, just reload your finger and go over that spot with more Blue.

3 Now we're going to add in sky using Horizon Blue all over the canvas. Let's divide this into the top, middle, and bottom layers of clouds. For the top layer of clouds, imagine you are creating an abstract hand pattern, with "fingers" coming into crevices of the clouds, filling in between the white and the purple. The patterns on the middle layer should be long skinny triangle/ finger shapes. The patterns on the bottom layer should be hodgepodge shapes, and the patterns at the bottom should be just dashes. Think of it as finger-like peaks on the top layer; skinny triangles with mild peaks in the middle layer; and small dashes with not much shape on the bottom layer. Here's what your painting should look like at this point.

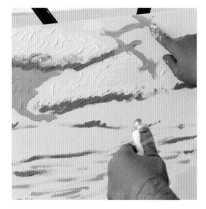
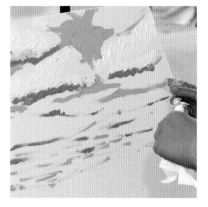
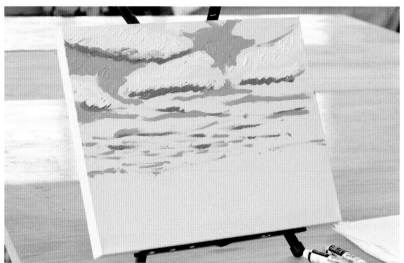

Add Texture to the Clouds

1 Clean your fingers and pick up the Titanium White. Place a chickpea-sized amount on your pointer finger and continue with creating muffin-top patterns at the tops of the clouds in the middle layer of clouds. A little contamination with the Blue and Lavender is okay but clean your finger before continuing. Reload paint as needed. Remember to be chunky!

2 Continue applying the White in a less defined, loose squiggly-line pattern to the clouds in the middle layer. Move side to side rather than up and down.

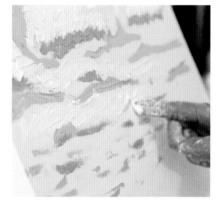

3 Add just a few strokes of White to the clouds on the lower layer using single, short strokes in between the Blue and Lavender.

4 The most important part is an alternating white, purple, blue zigzag pattern across the entire canvas. Here's a trick: squint your eyes so that your painting appears blurry and look for distracting zones of monotony. What you're trying to do when you squint your eyes is SEE the landscape like you're really standing and looking at the sky, and then react to "unnatural" components of that "real" scene you're pretending to be peering into.

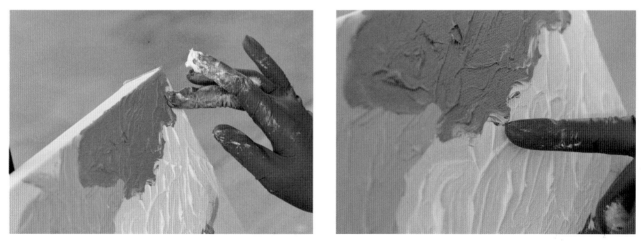

5 Clean your fingers and pick up Lavender. Place a chickpea-sized amount on your pointer fingertip and fill in the white space in the upper-right-hand corner, going around the edges of the white muffin top loosely. It's okay to collide the Lavender with the White here a bit—in fact, it makes the top edge of the cloud look its best!

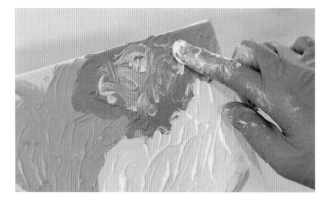 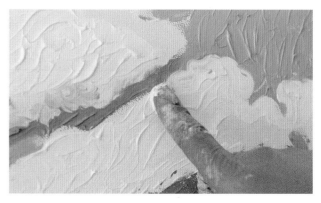

6 Clean your fingers and pick up Titanium White again. We are going to create the textural underbelly of the Lavender cloud in the top-right corner, which is predominately Lavender, but tinted with White. Place a chickpea-sized amount on your pointer finger and make light half-circles in a squiggly-line motion inside the Lavender, being very light on the touch. It should be a continued line; try not to pick up your finger. It's a long, scriptive movement, like writing cursive letters on top of each other. Clean your fingers and reload paint as needed. Use a light touch and roll your finger a bit.

7 Now we're going to continue this long, scriptive pattern with the White on the rest of the canvas between the blue sky and the white muffin tops of the clouds. Clean your fingers and reload White on your pointer fingertip. Beginning with the clouds bordering that big chunk of blue sky at the top of your canvas, apply the scriptive pattern along the edge of the White and Blue, going right up to the edges of the Blue and the purple. You'll start to see that the collision with the Blue creates this beautiful blended color. Resist the urge to go back over these lines—try to touch the canvas just once. Resist the temptation to get fixated on a specific stroke you have just made; move on, and for heaven's sake try not to keep touching and touching the canvas!

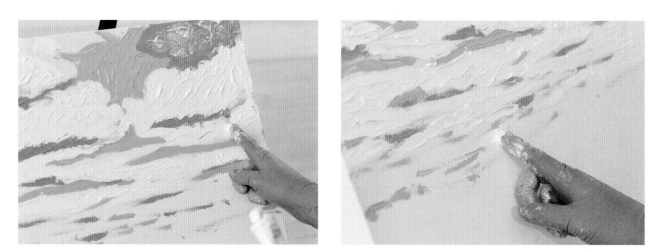

8 Continue to fill in any remaining canvas on the top third of the painting with Titanium White. As you get closer to the bottom of the sky you'll need just one or two swipes of paint on the canvas, as the space is smaller. Once you get to the bottom, your finger will be too fat to fit in between the blue lines so you'll kind of swipe over them and get this nice mixture of Blue and White. Be generous with the White because the texture will give the illusion of shadows. We don't want any canvas showing through. You can actually hear when there's too little paint on the canvas; it's when your finger makes a slight scratching noise. You'll know you're using enough paint if it's silent as snowfall. Remember to move side to side rather than up and down. Get rid of the canvas peeking through!

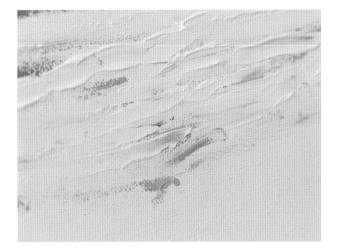

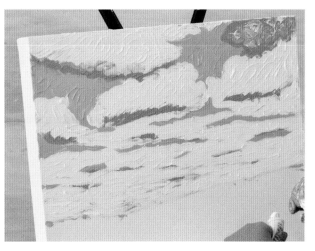

9 All of your strokes should be sideways, some short and some long. Do not paint vertical strokes going up and down. Should you inadvertently do so, you can easily move through the vertical lines with horizontal strokes.
Here's what your painting should look like at this point, after you've covered the canvas with White.

Make the Clouds Realistic

1 Wipe your hands like crazy—get all of the paint off them! Pick up Horizon Blue and place a pea-sized amount on your pointer fingertip. We're going back to the top-right corner to give that lavender cloud a hint of Horizon Blue. Starting close to the outer edges of the cloud, swirl the Blue into the Lavender/White combo to highlight the edges of the cloud.

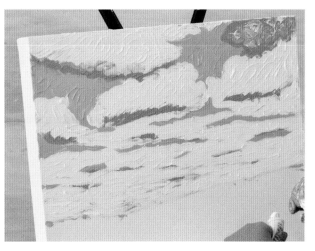

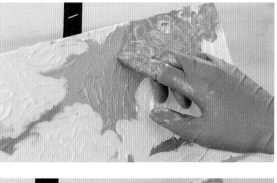

2 Clean your fingers and pick up Titanium White. Place a pea-sized amount on your pointer fingertip and with a very light touch, you're going to create the silver lining on that cloud just in between the Lavender and the Blue along the left edge. This will add some depth.

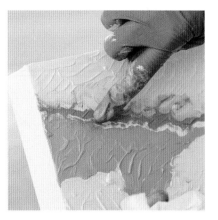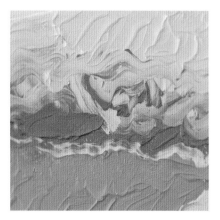

3 Repeat on the upper-left cloud with a feather-light touch. We are pushing the paints into each other and creating these beautiful color crashes that you wouldn't get with a brush. Pay attention to the pretty, nearly microscopic color collisions, with all these lovely swirls. Don't ruin those pretty accidents by touching them; leave them be.

4 Clean your fingers. We are going to activate the Lavender and the White paints. Beginning with the left cloud, push the Lavender into the White paint with one scriptive, swirling motion. You can change fingers to push the purple into the White, moving down the border. Pull from the existing Lavender on the border, but add more from the tube if there is not enough. Create fun squiggly, long cursive lines; these will mimic the texture of the inside of the clouds.

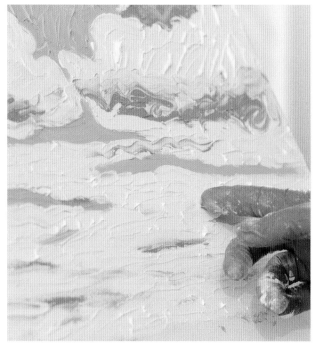

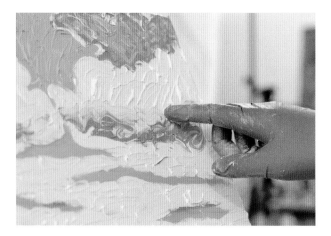

5 Clean your fingers and pick up Lavender. We're going to add this to the white cloud on the right side of the canvas just below the lavender cloud. Place a pea-sized amount on your pointer fingertip and, with a light touch, blend the Lavender into the white cloud, over the existing Lavender, in a wavy motion.

6 With the Lavender, create similar underbellies for lower clouds using a slightly less punctuated (looser) squiggly line to break up sections that are white-heavy.

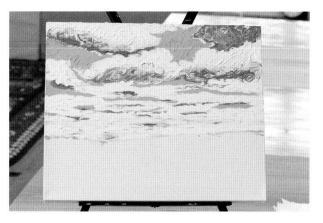

7 In areas where the colors may seem unrealistic, go back and work on blending and activating the Lavender into the White. Switch fingers here to blend and swirl the Lavender in wave-like patterns into the White. Where the Lavender appears too strong, swirl the White into the Lavender and vice versa. Wipe your fingers clean each time you go back to blend. Whenever you have too much of one color and not enough of another, prepare the fix by first cleaning your fingertips. Steal the color from the canvas you want less of, and push it into the other color.

8 Add purple to areas that look unrealistic or flat, filling in the underbellies. Let's step away from the clouds for a bit. Here's a good time to take a picture; if you hit any road blocks, send it to friends for advice. Document what things look like before they get over-touched. Here's a snapshot of what your painting should look like overall. It's coming together!

Begin the Field

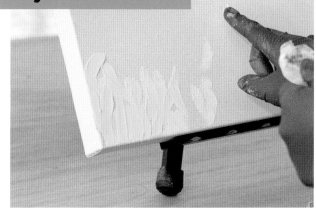

1 Clean your fingers and pick up Lemon Yellow. Place a chickpea-sized amount on your pointer fingertip and, beginning with the bottom-left corner of the canvas, fill in the white canvas with the Yellow using rough grass-like strokes. Do not go from side to side, like you did with the clouds, but rather up and down. If you create side-to-side strokes, just go over them with up-and-down strokes to correct the pattern.

2 You're going to go almost up to the blue horizon line on the left side of the canvas but not quite. Create a slight downward slope from the left of the canvas down to the bottom-right edge with the yellow grass line.

3 The top edge of the grass line should be a jagged abstract line. You'll get dots of negative space with the white canvas, which is good. Once you have the space mostly filled in with a pattern of negative white space, like I have here, stop!

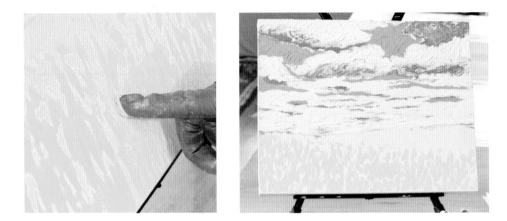

4 Clean your fingers and pick up Phthalo Green. Put just a small trace on the top of your finger. This paint goes a long way, so we don't want to use too much. Using a tiny dab pattern, dab the Green into the Yellow (stay away from dabbing it into the white canvas). The paint will last a long time (a trace amount will get you all the way across the canvas). Dance your way across the canvas, from left to right, creating peaks and valleys. Some areas can be blobby and some can be faint. Some can touch the bottom. It's important to be random and to create an irregular pattern.

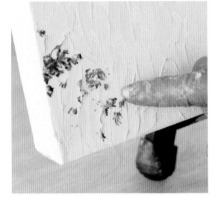

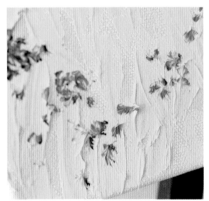

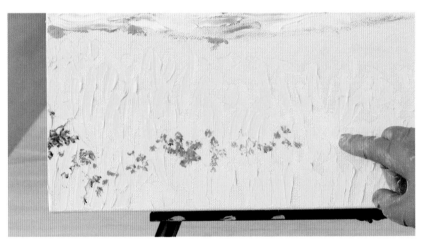

5 In spots where it still looks too yellow after you've reached the right side of the canvas, go back and create a second tier on the top or bottom of the first green pattern. Once you begin to lose the Green, stop the pattern. If the painting still feels too yellow, reload a very small amount of Green.

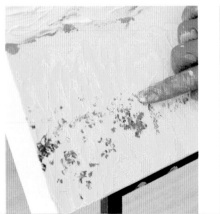

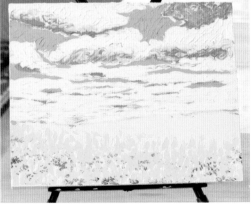

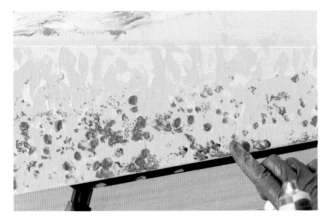

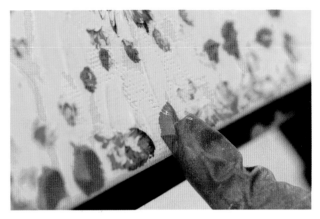

6 Clean your fingers and pick up Luminous Orange. Find the white canvas showing in between the Yellow (the negative space) and dab the Orange generously into those white spots. Stop and clean your finger after several dabs and reload the Orange. Be random! Don't create a polka-dot dress. Be sporadic, and then clustered. Focus the orange dabs on the left side of the canvas, fading them off as they get closer to the right.

7 The closer to the bottom of the canvas, the chunkier the dots should be. These will be the flowers in the foreground.

Add Flower Line

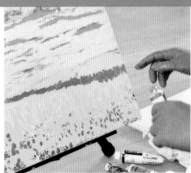

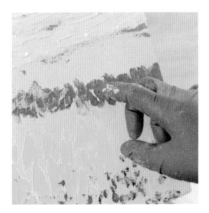

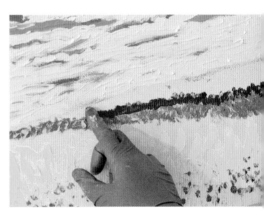

1 We're now going to create flowers in the distance by painting a line of Luminous Orange, beginning where your grass line begins and sloping down to the right side of the canvas. We are going to follow the slope of the grass line with the Orange in a tight grass-stroke pattern all the way down. Place a chickpea-size amount on your pointer fingertip and dab the Orange onto the canvas. Use short up-and-down strokes in a tight pattern, getting thicker as you continue right. Reload the paint as needed.

2 Clean your fingers and pick up Lemon Yellow. Place a chickpea-sized amount on your pointer fingertip and dab the Yellow into the Orange to tone it down. Wipe your finger after a couple of dabs and reload the paint. You can also use several fingers to dab at once.

3 Clean your fingers and pick up Luminous Opera. We're going to create another band of flowers in the distance. Place a chickpea-sized amount on your pointer fingertip and, beginning at the right side of the canvas, dab the top of the orange flower line, moving left. Do not create a straight long line; it should be more abstract than that. Dab almost to the crease of the orange flower line. Once you reach the crease, go back and add a few more dabs to create a thicker band of Red. Clean your fingers and reload paint as needed.

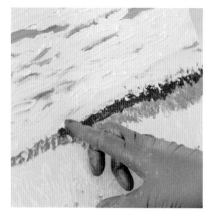 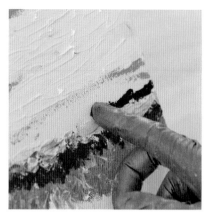 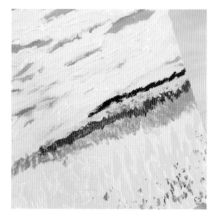

4 Clean your fingers and pick up Lemon Yellow. Place a chickpea-sized amount on your pointer fingertip and dab a thin band of Yellow on top of the red dabs. This stroke should be less of a dot pattern and more of a line all the way to the right edge of the canvas. Clean your fingers and reload paint as needed.

5 Clean your fingers and pick up Luminous Violet. Place a chickpea-sized amount on your pointer fingertip and paint short right-to-left strokes in a disrupted line above the yellow band.

Finish the Sky

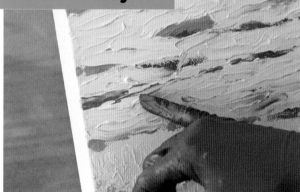

1 Let's change gears and go back to the sky. Clean your fingers and pick up Lavender. Go back to spaces where there is a lot of white, and paint scriptive, squiggly lines into the White to break up the monotony of the White. The closer to the bottom of the sky, the skinnier the purple lines need to be. Do not make them too fat. The more lavender lines you add, the more dynamic your clouds will look. Clean your fingers and reload paint as needed; you won't need to reload paint every time. Some of the lavender strokes should trail off.

2 I'm going to fix the right side of my canvas by breaking up some of the White and the color blocks created from the Lavender, White, and Blue. If you notice you've added too much Lavender, just push the White paint into the purple to make the White more dominant.

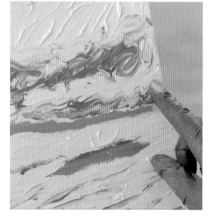 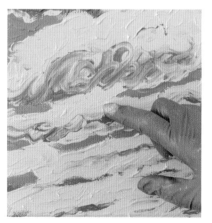

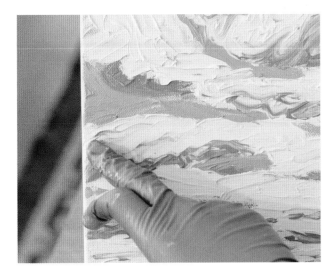

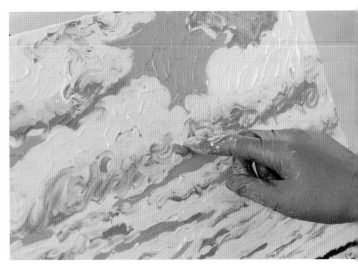

3 I'm also going to add some more Lavender to the clouds on the left side of my canvas, continuing to push the Lavender into the White in a squiggly-line pattern, moving along the color border of the Lavender and the White.

4 Continue to add Lavender to places that are too white. Lavender always creates the illusion of a cloud having a shadowed underbelly.

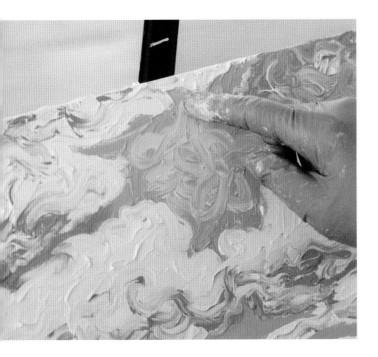

5 If the blue sky areas are too flat, clean your fingers and pick up Titanium White. Place a pea-sized amount on your pointer fingertip and in a very light scribble stroke, apply the White into the Blue at the top right of the canvas. Go right up to the border of the clouds, but avoid mixing the paints. Swirl in just enough White to make the Horizon Blue sparkle, but don't overpower the nice sky color!

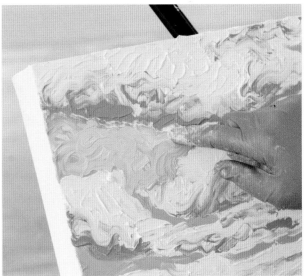

6 Repeat in the blue quadrant on the left side of the canvas. If you use too much White, just reload Blue from the canvas and push back into the White.

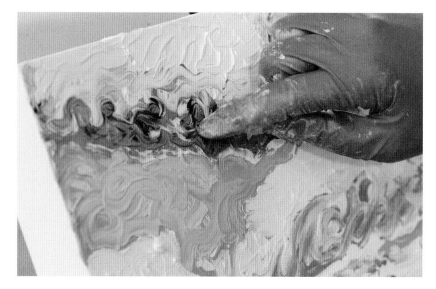

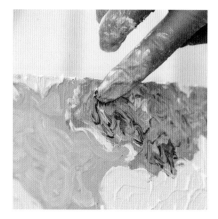

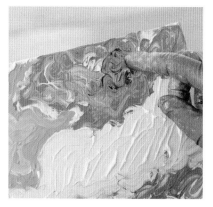

7 Clean your fingers and pick up Cobalt Blue Hue. Place a very slight tint on the tip of your pointer finger. Starting with the upper-left cloud, swirl the Blue into the all-lavender zones. (The clouds that are already blended with White and Lavender don't need the Blue.) Clean your fingers and reload paint as needed. This makes the Lavender pop by adding lowlights.

8 I'm also going to use the Cobalt Blue in the upper-right-hand corner of my canvas, because my cloud is very lavender-colored. I'm creating a very light swirly pattern, not picking my hand up too much. Apply the Cobalt Blue on the underbelly of the cloud, and not into the White.

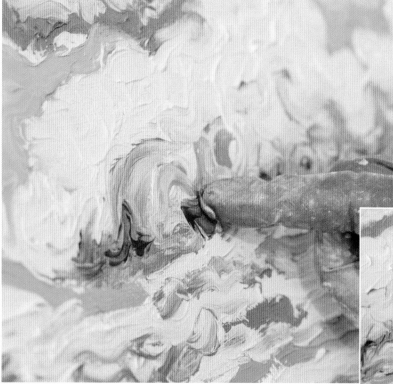

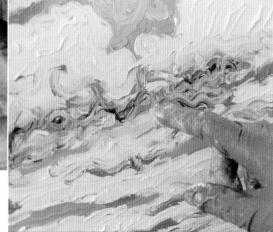

9 I'm also applying Cobalt Blue into the clouds in the middle layer.

10 Step back and look at your painting to see if there are any spots that are flat or too focused on one color and address by swirling Lavender into the White, or applying Cobalt Blue to the underbellies of clouds.

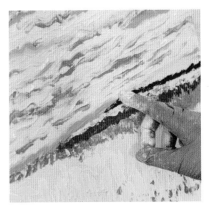

11 Clean your fingers and pick up Titanium White. Place a chickpea-sized amount on your pointer fingertip. We're going to finish off the clouds by defining some of the tops of the clouds with a very light touch where the Blue is too prevalent, moving the white of the cloud tops into the blue of the sky. Lots of fun little accidents will begin happening now with these colors. The tops of the clouds in the center and bottom of the sky will begin blending into the Blue, which is fabulous. If you overdo it, and want a more defined cloud top, just create a new muffin top with the White.

12 Clean your fingers and pick up Horizon Blue. Place a chickpea-sized amount on your pointer fingertip and apply a thick line that begins at the crease of the Luminous Orange flower line, moving over the Luminous Violet flower line to the end of the canvas on the right.

13 Clean your fingers and pick up Titanium White. Place a chickpea-sized amount on your pointer fingertip and run it over the top of the Blue. Use short left-to-right strokes to create a jagged white line over the Blue near the Luminous Orange flower crease (not covering the entire blue line).

Now's a good time to break for lunch. Step back from your painting for a bit and come back to it with a fresh set of eyes.

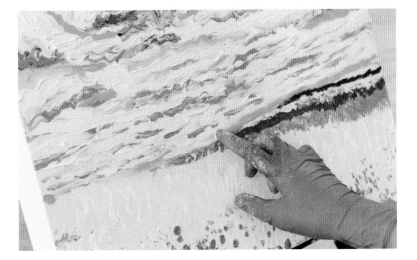

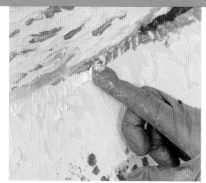

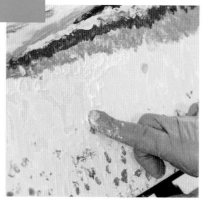

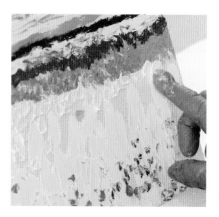

1 Okay, after you've eaten lunch, put your gloves back on and pick up Titanium White. Place a chickpea-sized amount on your pointer fingertip and, beginning at the left edge of the canvas right above the yellow grass line, fill in the white space of the canvas in between the Yellow. It's okay to touch the Yellow slightly, but clean your fingers and then reload White each time. Follow the bottom of the orange flower line and work your way to the edge of the right side. Reload paint as needed.

2 As you move to the right side and get about three-quarters of the way there, begin to dip down into the Yellow with the White and dab the White into the yellow grass randomly. Clean your fingers and reload paint as needed.

3 Finish dabbing the White to the right side of the canvas.

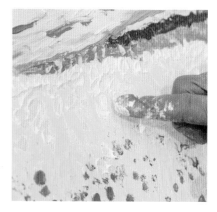

4 Now we're going to continue dabbing the White into the lower part of the yellow grass, making larger dabs coming down the canvas toward the bottom. As the dabs get lower, they should get larger. It's going to be impossible not to mix the White with the Yellow but do your best to keep cleaning your fingers and reloading so the colors don't blend too much.

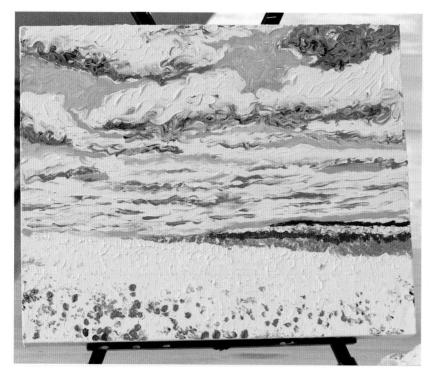

5 Here is what your painting should look like at this point. If you need to continue adding some White or adjusting any other colors, now's the time to do it.

Create Tulips

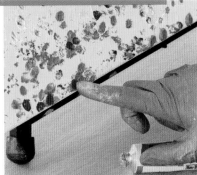

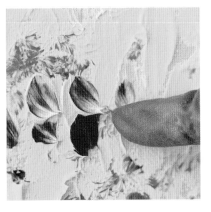

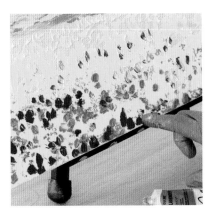

1 Clean your fingers and pick up Luminous Opera. We are going to dab over the Yellow, White, and Orange with thicker top-to-bottom strokes that will look like tulips. Create random clusters that cascade toward the bottom of the canvas. Use different dab sizes, some larger dabs and some smaller, wispier strokes.

2 We're creating tulips that are white and pink here. Dab the Luminous Opera into the Orange paint too, to break up orange clusters. Don't cover the Orange completely; we want to collide the three colors in the grass slightly. Look at how luscious this is! Clean your fingers and reload paint as needed.

3 Clean your fingers and pick up Naphthol Red. Dab it into spots where there is too much Yellow. Remember, the dabs should be larger the closer they are to the bottom of the canvas and much more faint at the top. This will give the illusion of depth.

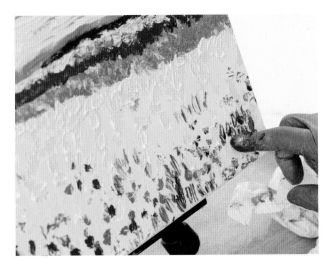

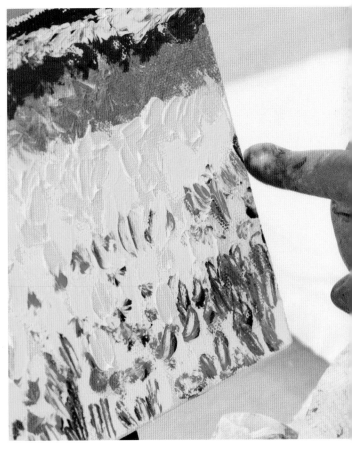

4 Here's where you can veer off on your own a bit. Work on continuing to create clusters of flowers and greenery. We're going to work back and forth with Luminous Orange and Luminous Opera, but first I'm going to add some more Phthalo Green to add further lush greenery. Clean your fingers and place a tint of paint on your pointer fingertip. Blend the White and Green with small downward dabs. I'm creating clusters on the bottom-right side of my canvas and middle-left side. It's a combination of dotting and dragging small drags.

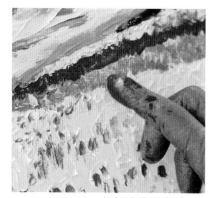

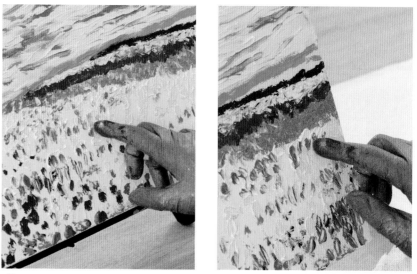

5 Clean your fingers and pick up Luminous Orange. Place a chickpea-sized amount on your pointer fingertip and dab the Orange into the White, starting on the left side of your canvas near the top of the grass line. The dabs should be small, wispy, and nondescript at the top of the canvas, like this.

6 You should get about 4–6 dabs per dot of paint on your finger. Clean your fingers each time and reload paint as needed. Dot the Orange all the way across the right side of the canvas, coming across the horizon line.

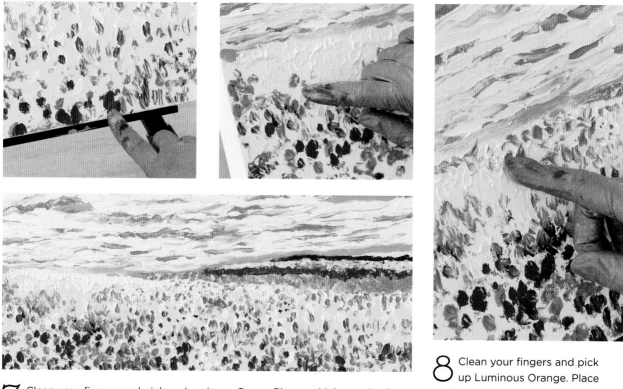

7 Clean your fingers and pick up Luminous Opera. Place a chickpea-sized amount on your pointer fingertip and continue dabbing: large dabs toward the bottom of the canvas and smaller wisps at the top. It's okay to overlap with some of the other colors, and fill in any remaining white canvas with the pink.

8 Clean your fingers and pick up Luminous Orange. Place a chickpea-sized amount on your pointer fingertip and dab the Orange into the White on the horizon line on the left side of the canvas.

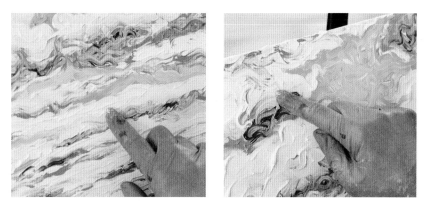

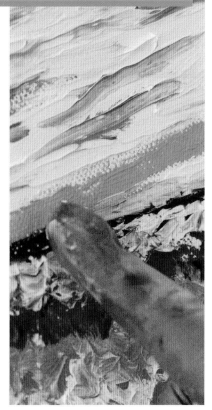

2 Clean your fingers and pick up Cobalt Blue Hue. Place a chickpea-sized amount onto your pointer fingertip and squiggle into the Lavender at the edges of the clouds. Squiggle left to right, without picking up your finger. Squiggle into the areas where clouds are too lavender or too white. Clean your fingers and reload paint as needed.

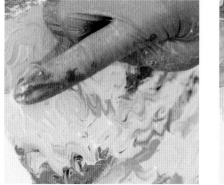 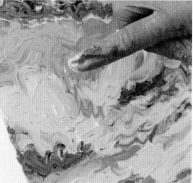

1 Clean your fingers and pick up Titanium White. Place a pea-sized amount on your pointer fingertip and drag lightly across the Luminous Opera (purple) from right to left. You're going for more of a violet color, which will make the horizon line look foggy.

3 In any place where the white muffin tops of the clouds are too distinct, pull the Horizon Blue into the White using a squiggly-line motion.

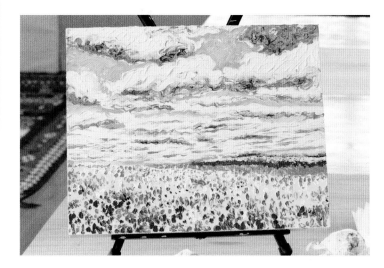

4 Now is a good moment to step back and ask someone what NOT to touch. Do your clouds look finished? Do you need more colors in your grass? Here's a shot of how your painting should look at this point.

5 Clean your fingers and pick up Titanium White. Place a chickpea-sized amount on your pointer fingertip and dab over any clusters of colors like the Red, Green, or Orange. Use larger dabs closer to the bottom of the canvas. Clean your fingers and reload paint as needed.

6 Clean your fingers and pick up Horizon Blue. Place a chickpea-sized amount on your pointer fingertip and dab lightly into the Yellow or in any spots that are too mono-colored.

7 Now here's a trick: squint your eyes and step away from your painting. Looking at the painting with blurry vision will enable you to see blocks of color you need to fix. I need to fix the white block in the middle of my valley. I'm using more Luminous Orange to create flowers, smashing the Orange directly into the Red.

Make the Finishing Touches

1 We're almost done! Clean your fingers and pick up Titanium White. Place a chickpea-sized amount on your pointer fingertip and dab big chunks randomly into the grass area in the bottom part of the valley. Use an up-to-down stroke, swiping the painting just once with each stroke. Clean your fingers and reload paint each time you dab the painting.

2 Clean your fingers and pick up Luminous Orange. Place a chickpea-sized amount on your pointer fingertip and, with a very light touch and moving top to bottom, swipe the Orange over the white dabs. Clean your finger every time. A little White peeking around the sides of the Orange is okay; it creates a sense of reflection and highlight. Pass it again very lightly if it doesn't go on the right way at first.

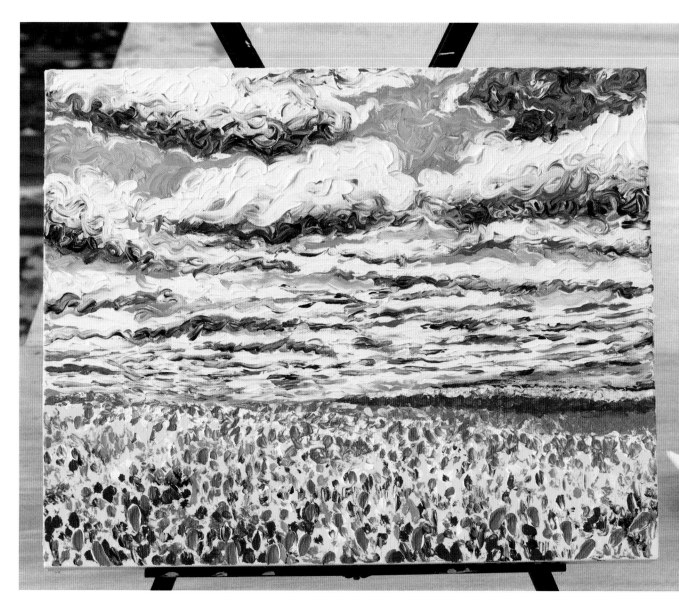

3 If you are going to frame your painting, you don't need to paint the edges. If you're not going to frame it, paint all four sides by continuing the image around the sides of the canvas. Let your painting dry for 3–4 weeks. Wire the back and hang, and you're all finished!

KOI FISH

The very first thing I want you to do before you begin this painting is to let go of any obsession you may have with achieving perfection. Finger painting koi fish is all about using a gluttonous painting method. It's much more fun and rewarding when you trust the thick paint. This particular koi image is from above, as if one is looking down into a pond. The painting is done in three basic layers—the water, the fish, and the lily pads. Koi are very forgiving because their markings already resemble that of paint and the water ripples look like swirled oils.

If at any point you find yourself questioning whether you're going in the right direction, take a step back from the painting and look at it from afar and from different angles. New perspectives are helpful and informative and it's always good to know whether you've strayed too far from your intention. If you have, I have some tricks to help you get back on track. Set up your canvas and have a roll of paper towels nearby. Pop the caps off your paint tubes, put on your gloves, and let's get started!

MATERIALS

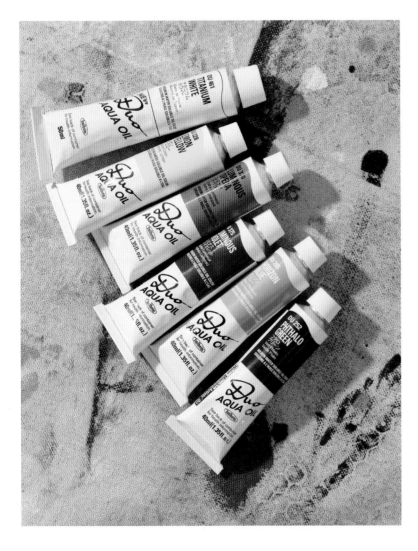

What You'll Need:
latex gloves; 16 x 20-inch (41 x 51cm) or smaller canvas (don't go larger for this painting); easel (optional); roll of paper towels

6 oil colors: Titanium White, Lemon Yellow, Luminous Opera, Luminous Violet, Horizon Blue, Phthalo Green

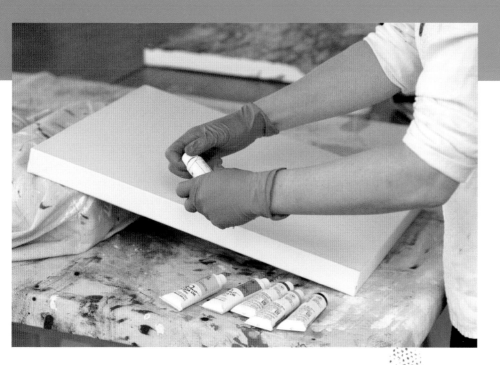

◄ Set up your canvas vertically and place your roll of paper towels close by. Put on your gloves and remove all the paint caps.

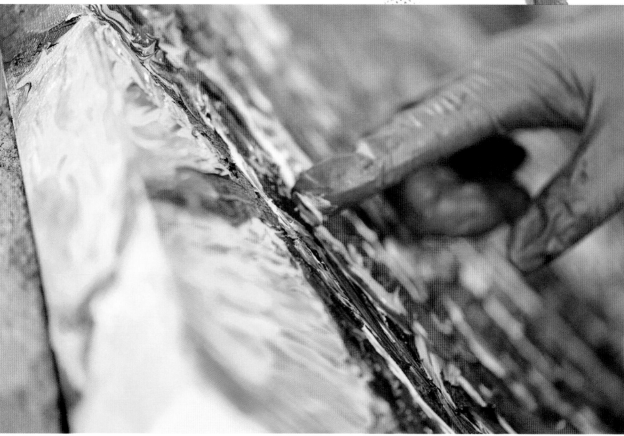

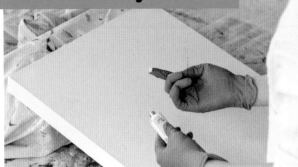

1 We're going to start with the lily pads. Pick up the Lemon Yellow paint and place a pea-sized amount (a regular pea, not a chickpea!) on the very tip of your finger. We use the tip because it will give us more control when painting.

2 Draw a small circle, roughly the size of a quarter, about 4 inches (10 cm) from the top-left corner of the canvas. The top of the circle should touch the top edge of the canvas.

3 Take a pea-sized amount of Yellow again, and 3 inches (7.5 cm) to the right of the first yellow circle, starting from the top edge of the canvas, draw a half-circle around the first circle. When you run out of paint, you'll feel the canvas "grip you," meaning that you'll be able to feel it beneath the paint (it will feel scratchy if you need more paint, smooth when you have enough). It's time to get another pea-sized amount. You'll probably have to reload your finger about 4 times.

4 With a pea-sized amount of Yellow, make another small circle, roughly the size of a quarter, about 6 inches (15 cm) from the top on the left side of the canvas. Unlike the first quarter-sized circle, this one will come close to touching the left edge of the canvas, but not quite. With Yellow, draw a half-circle around that circle so that it slightly overlaps with the half-circle from Step 3. Reload your finger with paint when needed.

5 About 5 inches (12.5 cm) from the bottom of the canvas, make a "D" shape with the Yellow paint against the left side of the canvas around the bottom-left corner. This will be the third lily pad, but it will not have a center.

Fill in the Lily Pads

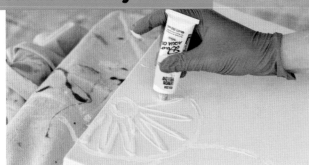

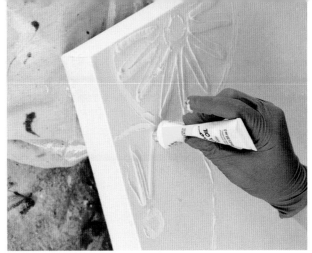

1 Now this is the fun part! We're going to fill in the three lily pads with Yellow paint. The more paint you use, the easier it's going to be. There are bunch of different ways to get the paint on, but my favorite is to apply it right to the canvas like you're putting mustard on a hot dog. Gently squeeze the tube and move up and down in a sun-ray pattern on the first lily pad. Lines should be fairly thick. Don't touch the center circle.

2 Repeat for the second and third lily pads.

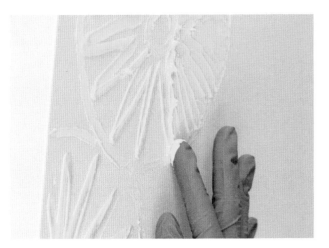

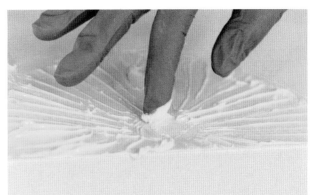

3 You want to create that veiny texture of the lily pad in this step. Using your fingertip, fill in the paint like you're frosting a cake. Use your fingertip to move either from the outside of the circle inward toward the center or vice versa, filling in the white and covering it by redistributing the paint. Make sure to go in only one direction; this will be an advantage as you progress through the painting.

4 Fill in the second and third lily pads, going in the same direction as you did the first lily pad.

5 If you have extra paint on your finger and don't want to waste it, place it on the side of the canvas next to one of the existing yellow circles. Painting the sides of the canvas make the painting look very finished. Do a rolling motion with your finger, side to side, until the paint comes off.

Outline the Koi Fish

1 Now we're moving on to the koi fish. We'll paint three total. If you
 want to outline them first, you can use a pencil or marker to trace
their general shape. Using a banana, create two parallel lines, rounded at
the tip. We don't want those big fat round fish we drew as kids, though,
so think of these fish as shapes and not fish.

2 Now pick up the Luminous Violet
 paint and place a pea-sized
amount on your fingertip (remember,
it's a regular pea not a chickpea!). The
first of two fish will go in between
the second and third lily pads. Draw
a violet line, coming out of the left
side of the canvas (starting directly
between the lily pads), sloping down
(following the shape of the bottom lily
pad) and stopping about 2 inches (5
cm) from the bottom of the canvas.

3 Draw a parallel line below this
 line, and then incline it upward
toward the end of the first line so
that it joins the end of the first line.
You'll have to reload your paint
several times. To make the tail, paint
a loose squiggly line that trails off at
the end of the fish.

4 Before starting the second fish, using the Luminous Violet, make a dot as a
 reference point for the third fish in the center of the canvas.

5 Make another dot above and to
 the right of the center dot. The
second point is going to be the nose
of the second fish. Draw a "V" shape
with the second dot as the center of
the V. From the top of the canvas,
draw a soft line sloping to the left,
with the end of the line centered
in the V to create an arrow. Think
banana shape! Koi are quite narrow
when seen from above.

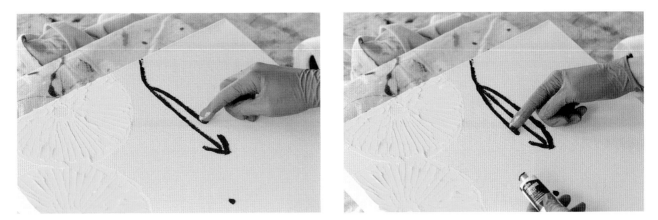

6 About one-quarter of the way down the soft line, draw two loose bracket lines that attach to the ends of the V. This finishes up the outline for the second fish; we'll come back to it later.

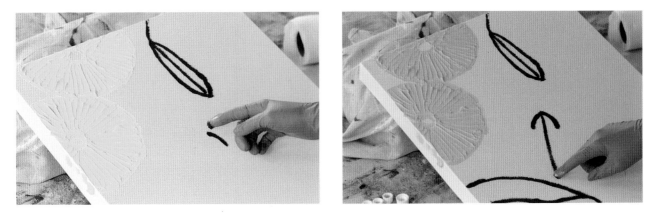

7 The third fish is the largest. The nose starts at the reference dot we made in the center of the canvas in Step 4. From the dot, draw a loose wishbone shape, with the dot at the top of the wishbone. You'll want to make this more of a rounded shape as opposed to the V shape you painted in Step 5 for the second fish. From the center of the wishbone, draw a straight line down to the first fish, stopping at the first violet line.

8 Draw another line for the wisp coming from the bottom of the first fish. Flare the line out to the right.

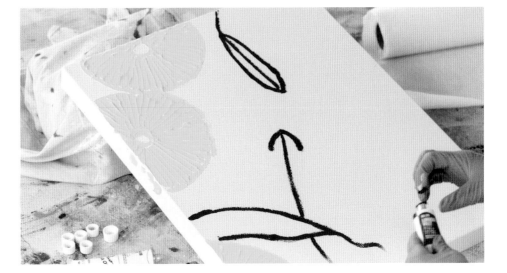

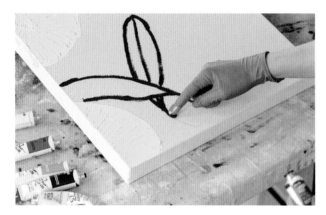

9 From the right and left wishbone ends, draw a line on each side until you reach the top of the first fish. You're going for the width of the banana here, not necessarily the curve of the banana.

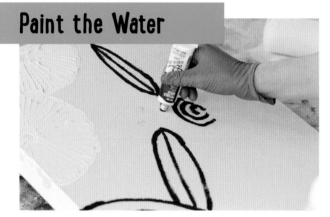

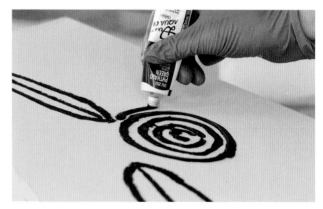

10 Fill in the tail at the bottom with Violet paint, adding more to make the tail larger if you like.

11 Add a line down the center of the first fish, following the curve of the fish's outline. Feel free to wipe any excess Violet paint on the side of the canvas using a side-to-side rolling motion.

Paint the Water

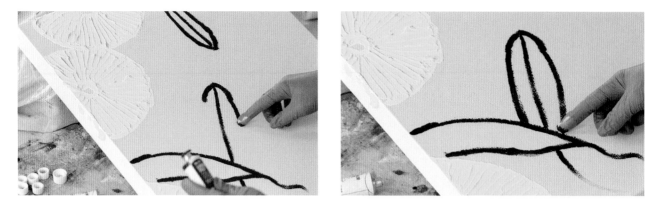

1 Now we're going to start the water, which will be a luscious dark green color. Squeezing the tube of Phthalo Green directly onto the painting (rather than using your fingertip, as in other steps) apply a series of circles, each larger than the next, in between the second and third fish on the right side of the canvas. This part of the process usually causes stress for people because they are afraid of making a mistake. The circles don't need to be perfect—you're going to fill in all of the white space with Green later anyway. Trust yourself and the paint, follow the steps, look at the photos, and you'll be fine.

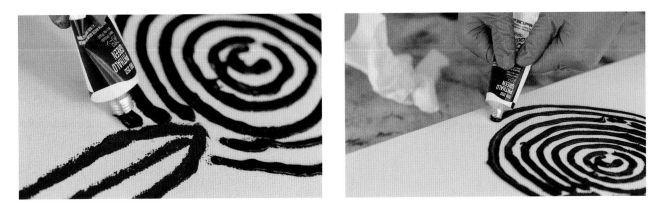

2 The green circles should come to the edges of all of the other elements on the canvas. Move down the tube and start squeezing from the bottom like with a tube of toothpaste. Everyone squeezes from the top for some reason! Use two hands here to apply the Green.

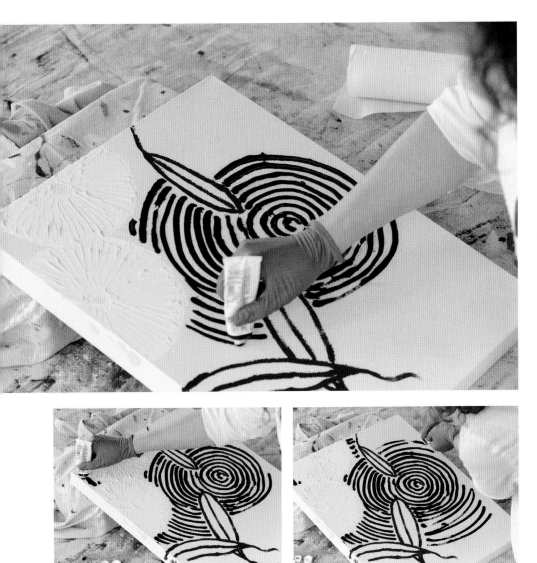

3 Continue with the Green for the entire canvas, stopping the circles just before the edges of the other paint colors. You'll go through the entire tube. If you begin to run out of paint as you finish the circles, you can take paint from the thicker green parts to fill in areas with less paint.

4 When you're finished with the green circles around the entire canvas, start pushing the green into the white space. The goal is to fill in the entire white canvas area, with the exception to the fish, with the green paint.

5 Follow the contour lines to create the texture of the water. Do several short strokes at a time, working your way out, filling all the white space. Don't overdue it! Let the paint do the work and resist the urge to fix things, it should be a little messy. Stick with concentric circle motion, going in one direction. If you need more paint, go mine for it in places on the canvas where there is excess. We are painting Impressionistic and chunky, here, so don't worry about coloring perfectly! Use one, two, or three fingertips to fill in all the spaces. Enjoy the feeling, you're really finger-painting now!

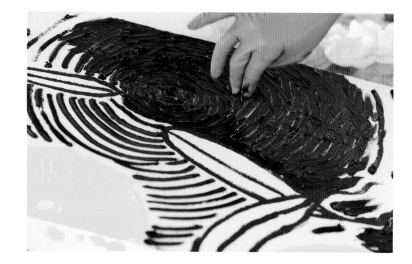

6 Go all the way to the edges of the fish and lilies. If purple or yellow paint get on your finger, that's ok, it will mesh into the colors of the water. The yellow of the lily pad and the green will make this beautiful bright grass green color that we'll end up pulling into the lily pad. Don't freak out if it's not perfect around the edges, it will add great colors when the colors combine, something unexpected. The paint will be chunkier than others in some parts, and that's what we're going for!

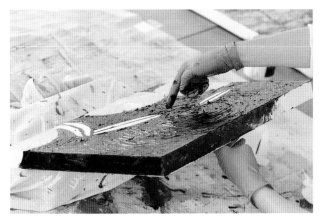

7 Now you can extend the Green around the edges of the canvas. Again, use a side-to-side rolling motion to transfer the paint to the side of the canvas. Use several fingers to grab any excess paint from the canvas and smear it on to the sides.

8 Once the sides are covered in Green, we clean our fingertips because this green is a very powerful color. Using a paper towel is more than sufficient to get the majority of the Green off—no water necessary.

Color the Koi Fish

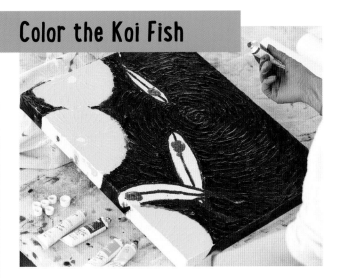

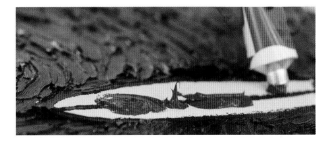

1 We return to the fish in the next few steps, which we will color using the Luminous Opera. Don't be afraid of it—we need to use a lot. It's called "luminous" for a reason: it's a bright, beautiful color! To make the spots and blotches of the koi, we are going to squirt the paint directly onto the canvas, starting with the fish of your choice. Place a generous, circular glob of paint on the top of the head of the fish. Repeat the circular globs on the other two fish.

2 On the first fish, paint two small lines on either side of the dorsal line (the middle line) of the fish, just below your big paint blob. Your lines should be about an inch (2.5 cm) long; the length will vary depending on the fish's size. The pink lines should overlap naturally with the purple dorsal line, so don't worry about the colors mixing.

3 Repeat on the other two fish. You should be using a lot of paint here . . . Are you? Don't be paint shy!

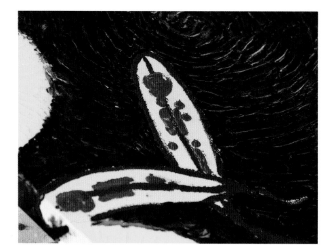

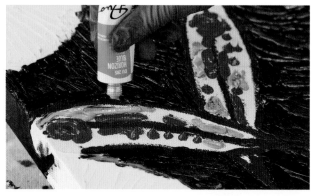

4 Inside the white space of each fish, squeeze dots of pink scattered along the fish. You can also put them along the tail. I position them in a loose line close to the dorsal line of the fish, with some near the head and tail.

5 Pick up your Horizon Blue paint next; we're going to fill in the white areas of the fish. It's going to be very chunky and, up close, will look extremely chaotic but if you step back and look at it abstractly, it's perfectly right.

6 Take the tube between your thumb and pointer finger and use the opening of the blue paint to color in the canvas, working around the Pink. (You're going to use your finger eventually to fill in the small spaces.) This is where all sorts of color accidents are going to

happen, all kinds of great swirls and color combinations. Don't be afraid of them!

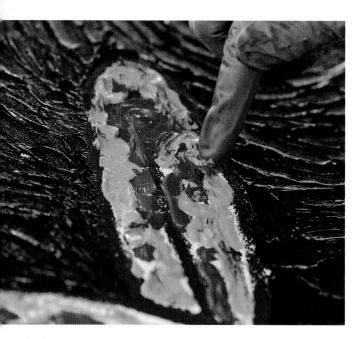

7 Use your fingertip to fill in all of the remaining white space. Gently try to get into all those nooks and crannies; the colors will swirl and combine in unique ways. No white allowed! Resist the temptation to keep touching the painting; you'll be thankful later.

8 Now's a good time to take a lunch break and step away from your painting for a bit. When you get back, look at it from different angles and think about what you're happy with and what you'd like to fix. Yes, there's always time to go back and fix things! Have a friend come by and look at your painting and get her opinion, too. Taking a break and having another set of eyes will help give you some perspective on your painting, and boost your confidence.

Highlight the Lily Pads

1 We're going to come back to the fish later and work on the lily pads again. Use your fingertip to take some Green on your finger from the water, anywhere on the canvas. With your fingertip, using a light touch, trace a squiggly line on the small circle of the first lily pad. Do not repeat the circle or go over it, only make the circle once.

2 Now you'll have some Yellow on your finger. Deposit the extra on the side of the canvas. Clean your fingers as needed.

3 Dab the canvas again to pick up some more Green and repeat again in the remaining lily pads. Remember to stop after making one circle.

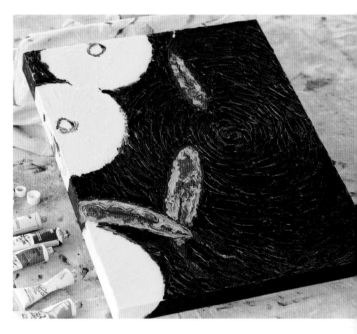

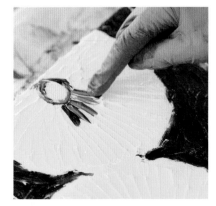

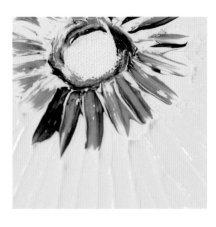

4 Dab your finger again in the Green and, moving outward from the center of the lily pad, make short strokes of Green. As you run out of dark green, the bright grass-green color you are creating by mixing it with the Yellow will get lighter, which is what we want! You want your colors to vary.

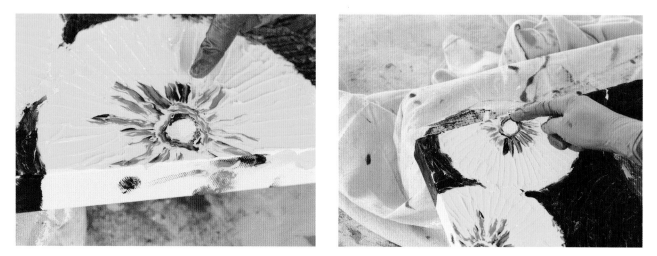

5 Repeat on the second lily pad. You can make some lines shorter or longer, some squiggly, some straight. Wipe your fingers with the paper towel if the paint gets too globby.

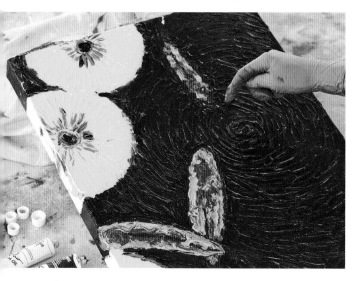

6 Grab some Green again from the canvas and fill in the center circle on the top two lily pads. No white space!

7 Take some Green paint from the canvas on your fingertip again, and going in an up-and-down motion toward the center and back, trace over the yellow rays you made originally by filling in the Yellow, in Step 3 (Fill in the Lily Pads, page 49). Go slightly over the edge of the lily pad to pick up more Green as you come back over the same edge, so that the Green and Yellow mix and pull up toward the center. If your lily pad is still too yellow, take more Green paint from the canvas. (Make sure to wipe your finger first.)

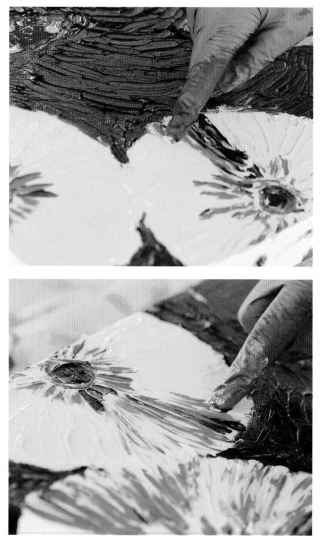

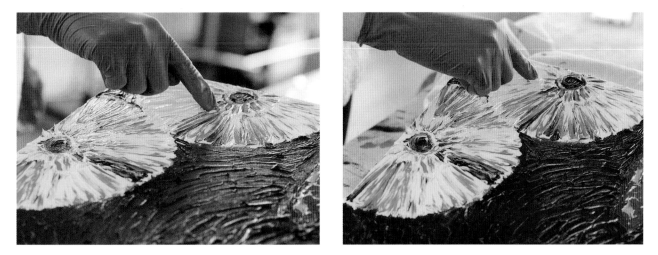

8 Reload the Green paint on your fingertips as often as you like until you find a pattern and color you like for each lily pad. Remember to go all the way to the edge—lily pads are messy around the edges.

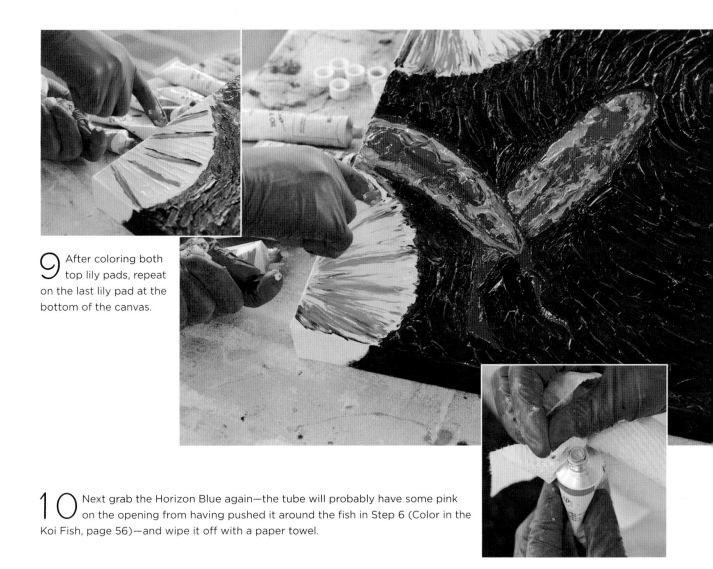

9 After coloring both top lily pads, repeat on the last lily pad at the bottom of the canvas.

10 Next grab the Horizon Blue again—the tube will probably have some pink on the opening from having pushed it around the fish in Step 6 (Color in the Koi Fish, page 56)—and wipe it off with a paper towel.

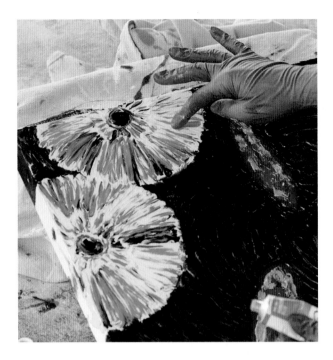

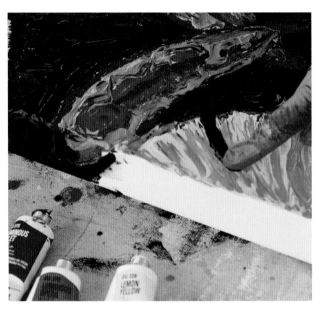

11 Dot your index finger with a pea-sized amount of Horizon Blue and press it on the rays—whether yellow or green—of the lily pads. Press lightly! You should get about three strokes out of each pea-sized amount (it will take about seven dots of paint per lily pad).

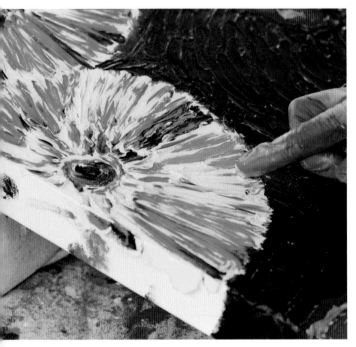

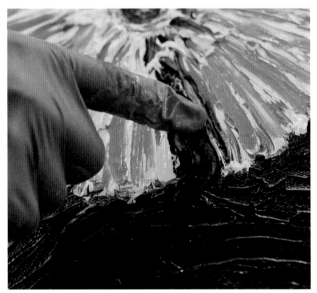

12 If any part of the lily pad seems too monochrome or doesn't have enough pizzazz, then use the Blue to add more color. The Blue is meant to add reflections from the sun. Let it be imperfect. Let the awkwardness of your fingertips play into the uniqueness of the painting. As your fingers pick up the Yellow and Green from previous layers, you can either wipe them or use other fingers to create more layers. This may get kind of messy . . . but let it!

13 Now we're going to create the splits in the lily pads. Using your index finger, grab a bit of Green from the canvas and push the Green toward the center of the lily pad, but not all the way to the center. You may need to reload with Green twice to get the split to really appear.

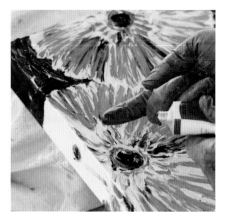

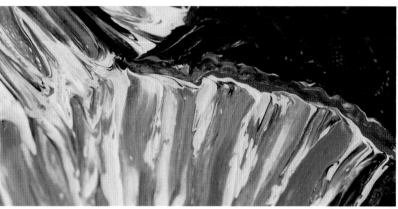

14 Clean your hands thoroughly with a paper towel. I like to add Orange to the lily pads, by squeezing a pea-sized amount of Luminous Opera along the edges of the lily pad (in a small spot, not all the way round) in a squiggly line. Run your finger over the edges only once!

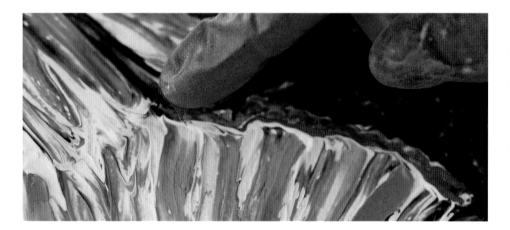

15 Repeat on each lily pad. Choose a spot that needs some highlighting or where there isn't much color or variety. This is a great place to add some light pink lines. You will create these places of mini color explosions!

16 Do the same for a few spots inside the lily pad. Create short squiggly lines about a quarter of the length of the lily pad, coming from either the center or the edge. These can be dabs, too; you can alternate the type of movement of your fingers and stroke.

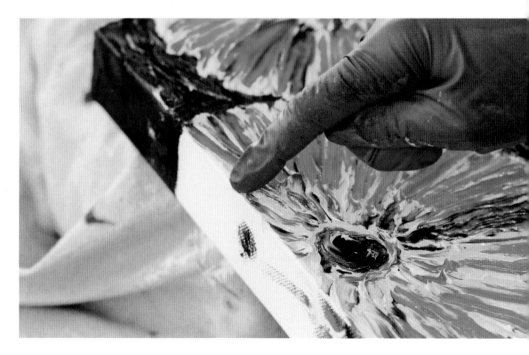

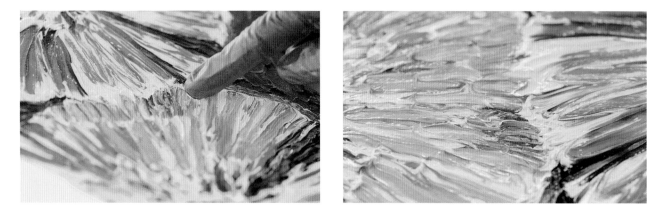

17 Add these lines in wherever you see "blah" spots in need of higher contrast. You can also use this technique to contrast the two lily pads on the top of the canvas by adding pink strokes to the top of the pad.

18 Pick the Horizon Blue back up (not forgetting to wipe your finger!) to fill in some spaces. Alternating colors will help you achieve that tidied look of a lily pad. You can go back to colors and add more streaks if you want your lily pads to be more green, yellow, or pink. It's all about personal taste.

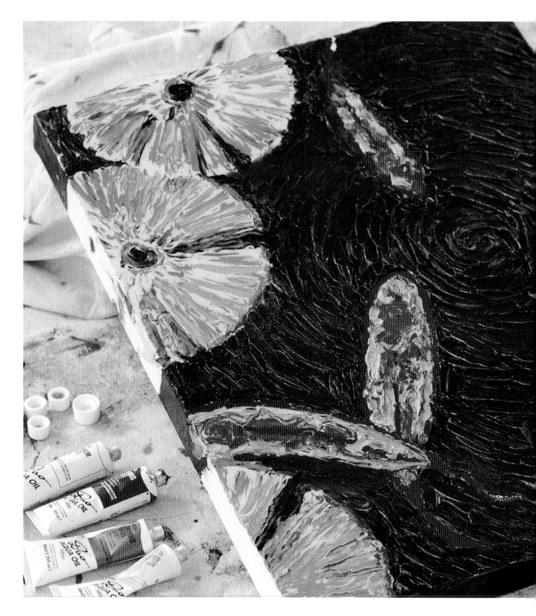

Paint Ripples in the Water

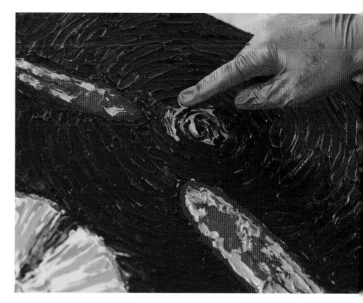

We're almost done! Each time you go back for more Horizon Blue, clean your fingertip (I keep the paper towel in my left hand during this part for quick cleaning).

1 Dot a pea-sized amount of Blue on your index finger and go back to the center of the ripple. You're going to make backward- and forward-facing "C" shapes with the Blue to create highlights in the original dark green paint. The eye of the "C" is going to fill in the illusion of ripples. Move out from the center and create these C shapes, touching lightly, following original contours, but the Cs should be whimsical. Make some shorter or longer than others, some squiggly lines, and some straighter. Perfect concentric circles is not what you want.

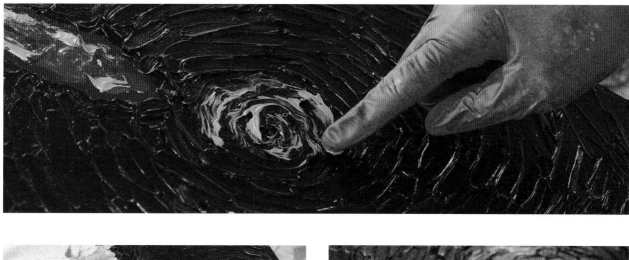

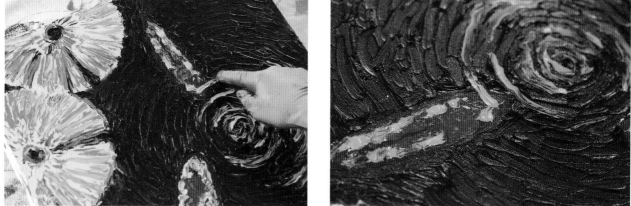

2 Run the light blue strokes right over the top of the fish. Start from the middle of the fish's body and paint outward, so you don't bring in any dark green to the fish. Clean your fingertip each time. Follow the old contour lines of the ripples and move from the fish into the water. It's okay for some of the pink paint to drag out into the green of the water. Make a couple of ripples per fish. Don't over-paint—go over the lines only once. Keep following the old contours: trust them!

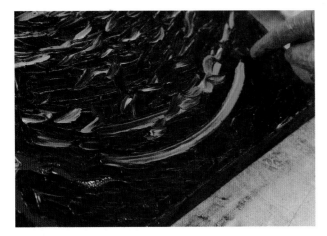

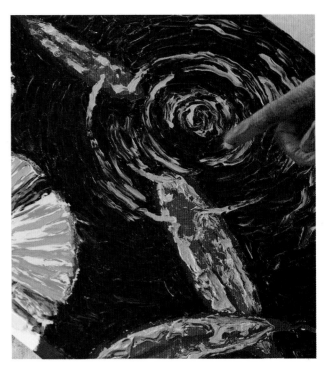

3 When the Blue runs out, clean your finger with the paper towel. If you press very lightly you'll get two or three strokes out of one pea-sized amount of Blue. If you mistakenly create too long and stagnant a ripple, just take the Green and make a squiggly line through the Blue to interrupt it. As you get away from the center, the Blue should be more muted (less blue and more dark green) and less defined.

4 Go right up to the edges of the lily pads with the blue ripple lines. Let the swirly blues and greens create the watery look for you.

Finish the Koi Fish

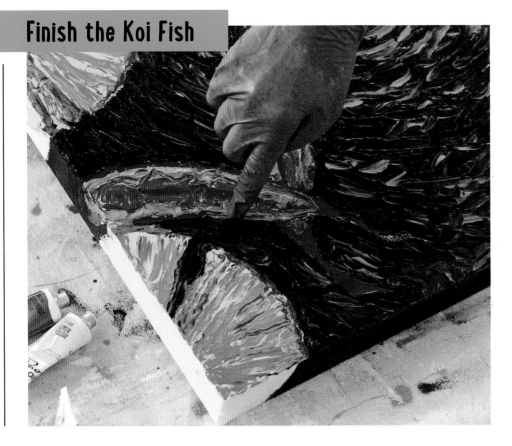

1 The fish should already be outlined in purple, but some outlines may have gotten lost through the steps. We're just going to strengthen the outlines here if they need it. Pick up the Luminous Violet and place a pea-sized amount on your fingertip. Run this lightly along the edges of each fish that needs a rounder look.

2 Add spots to the fish by first dotting your fingertip with Violet. Beginning from the inside edge of the fish, gently zigzag halfway into the fish and then create a messy triangle. Add the messy triangles on the bottom third of the body toward the tail, a few per fish. This will simulate splotches that wrap around the fish's body.

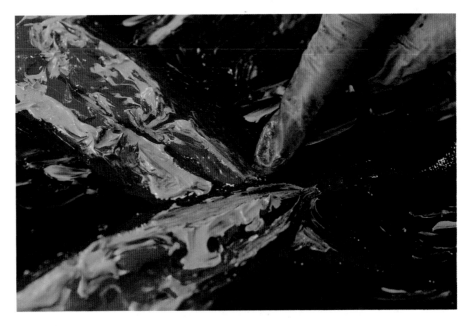

Make the Finishing Touches

Here's where you may need to go back and correct some things, such as adding more purple spots to clarify and contrast things. You may even need more ripples.

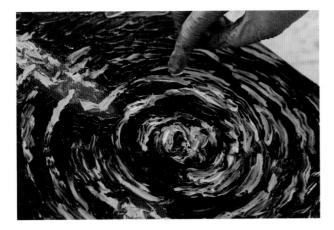

1 Now we're going to add reflections on the water with the Titanium White. You can use the White to highlight the blue ripples and the dorsal fin of the fish, and to create pools of water on the lily pads. We don't use the White to create water reflections for the lily pads because they sit on top of the water. Dab a pea-sized amount of White paint on your fingertip and with a light touch, add it on top of the blue ripples, following the contours of the Green and Blue paint.

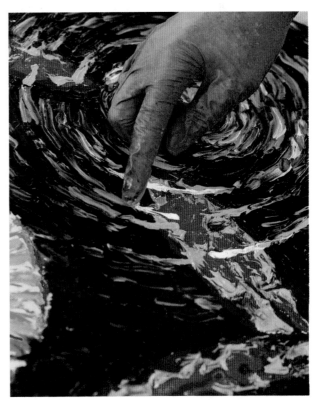

2 Add small and soft squiggly lines to some of the light blue lines. You can go over the blue lines of the fish, too, as the White will give the fish more depth. Start from the inside and paint out so you don't bring the Green into the fish.

3 If you accidentally bring the Green into the fish, simply wipe your finger clean and push the correct colors back into place. So, dip your finger in the blue of the fish (or pink) and push the color back.

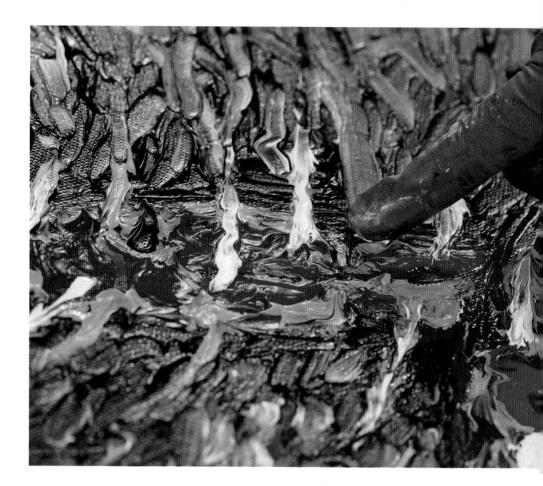

4 If the tails disappear, it's really easy to add them back in. Place a pea-sized amount of Luminous Opera on your fingertip and run a squiggly line alongside the purple, almost bumping into the purple.

5 With clean fingers, place a pea-sized amount of Lemon Yellow paint on your fingertip. You're going to create the suggestion of a line down the center of the fish. Create a few short broken lines down the middle of the fish. If the fish still looks disappeared, take a chunk of hot pink and add some squiggly lines to brighten them up.

6 If the picture starts to look too monochromatic or if you make too long a streak, just use a clean finger to swipe messily through the White into the Green and over. If you mess up near the lily pads, go right up to them and pull down the colors. Squiggle directly up into them.

7 This is it, folks! The last step, save for any final tweaks; yay! If you are going to frame your painting, you don't need to paint the edges. If you're not going to frame it, paint all four sides by wrapping the scene around the sides of the canvas.

8 Step away from your painting again and come back. Turn it around and upside down and look at it again. Ask a friend to look at it. Maybe you'll need more ripples, maybe you'll need to round out your lily pad, maybe you'll need to brighten your fish. Just remember not to touch it up too much; the painting should look impressionistic and messy. Make any necessary adjustments and you're done! Let your painting dry for 3–4 weeks.

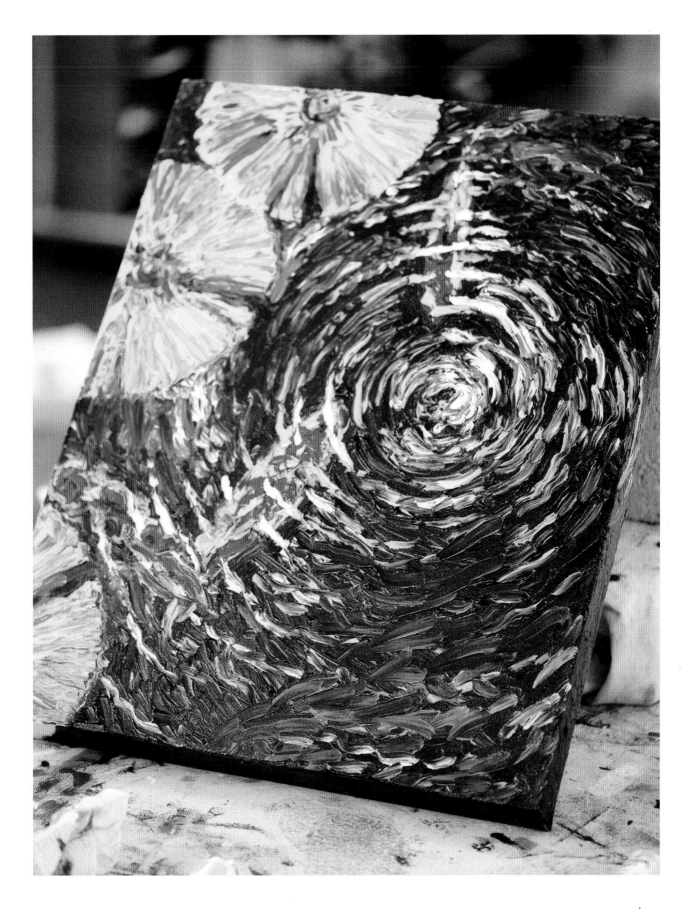

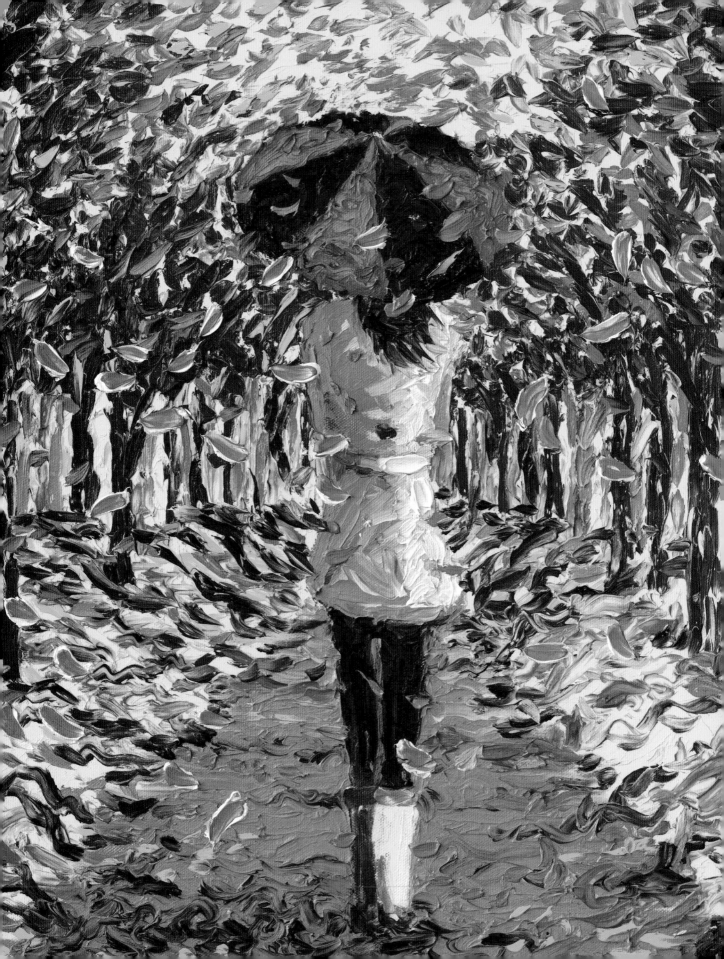

LADY IN LEAVES

If you do a Google Image Search for the word "paintings," this painting is one of the first images to pop up. I never expected in a million years that this painting would be so popular, but something about the color and composition really seems to resonate with people. Perhaps it's the symmetry, but this woman taking a stroll down a tree-lined path also packs a real punch in terms of its color palette. This is one of my favorite paintings, and its one that's popular with my students. I often teach it in my classes because it's such a colorful and energetic piece, and I find that it's perfect for everyone, even those who have never touched oils in their lives.

Remember, as you begin, that impressionism isn't exact; it's really about accepting the loose paint. I encourage you to stick closely to my instructions because even when everyone in one of my workshops copies an image, the results are unique and varied. I'm here to prevent you from becoming overwhelmed with the steps. Trust the paints; they will do wonders for you and provide you with the texture and dynamism that makes this painting so rewarding to complete. Don't skimp on the paint—you'll be happy you were generous with yourself. Let's get started!

MATERIALS

TOTAL PAINT
AND PREP
TIME:
4–6 HOURS
(TO BE DONE IN
ONE SITTING)

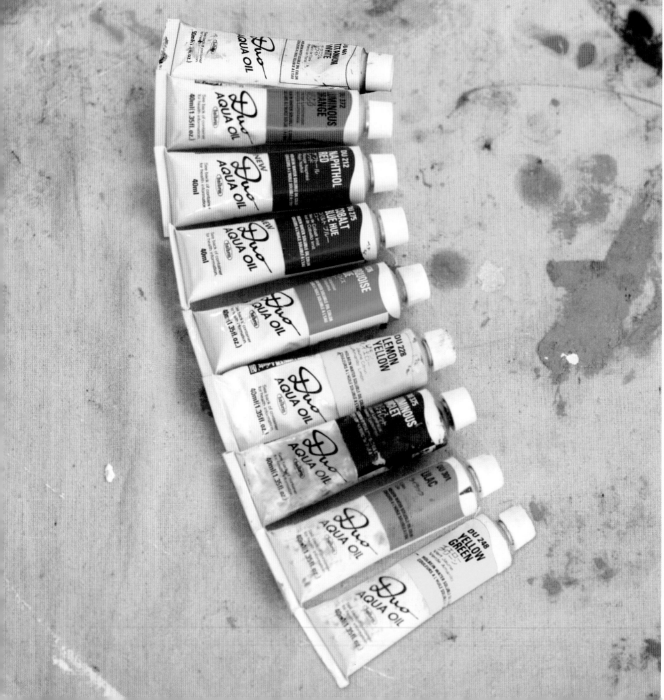

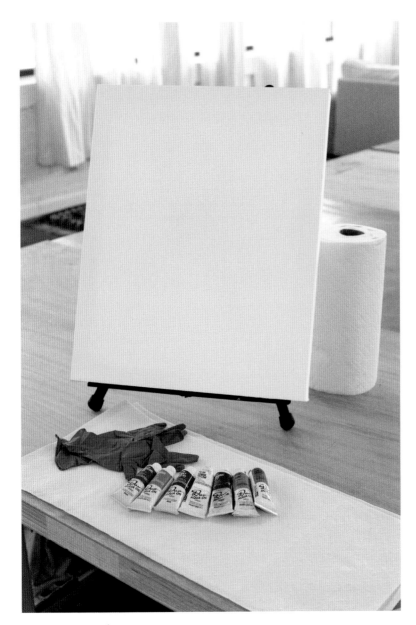

What You'll Need: latex gloves; 16 x 20-inch (41 x 51 cm) canvas; easel; roll of paper towels; pencil

9 oil colors: Cobalt Blue Hue, Turquoise Blue, Luminous Violet, Lilac, Naphthol Red, Luminous Orange, Titanium White, Yellow Green, Lemon Yellow

▲Set up your canvas vertically on your easel and place your roll of paper towels close by. Put on your gloves and remove all the paint caps.

Draw the Girl

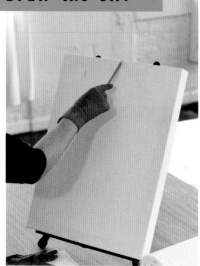

1 Using the pencil, draw a vertical line from the top center of the canvas all the way down to the bottom. This line represents the middle of the girl's body. Use a very light touch with the pencil, not too hard.

2 Draw a horizontal line through the center of the canvas, about 2 inches (5 cm) wide, to make a cross. This is the girl's waist.

3 Break the vertical line into 6 parts, by drawing 2 horizontal lines above and 2 horizontal lines below the central horizontal line from Step 2, spaced about 3 inches (7.5 cm) apart. These 4 lines should each be 1 ½ inches (4 cm) long.

4 To create the girl's hourglass-shaped coat, draw a line that slightly angles out and up from the center horizontal line toward the horizontal line above. Repeat, but this time draw the 2 lines angling out and down to the horizontal line below. Connect the lines horizontally to make an hourglass shape. Her waist should be about 2 inches (5 cm) wide and her shoulders and coat bottom should both be about 3 inches (7.5 cm) wide.

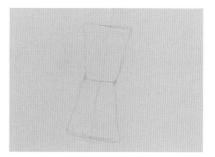

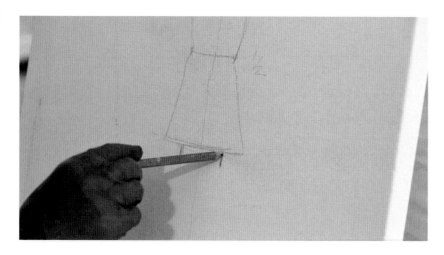

5 To create her legs, draw 2 vertical lines that slightly angle in to the horizontal line below, each about ½ inch (13 mm) in from the ends of the coat bottom.

6 To add the girl's rubber rain boots, draw a line a few centimeters out from either side of her legs and extend down, leaving about an inch (2.5 cm) from the bottom of the canvas.

Draw the Umbrella

1 With the pencil, draw an oval shape that extends about an inch (2.5 cm) outside the girl's shoulder width on either side, with the bottom of the oval almost touching the shoulders. Extend the oval shape beyond the top horizontal line by about ½ inch (13 mm). The top horizontal line will be the point of the umbrella where the sections meet.

2 Draw a vertical line straight down the middle of the umbrella, through the horizontal line to the bottom of the umbrella.

3 In the center of the horizontal line, draw a darker dash-like pencil line.

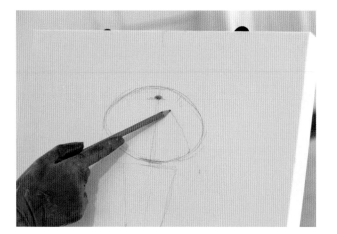

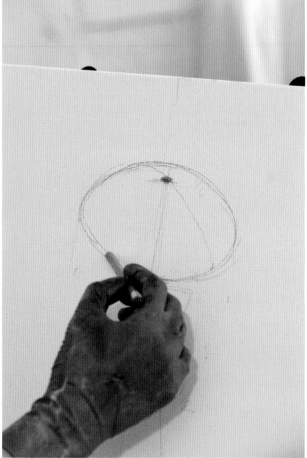

4 Now, we'll draw the umbrella's ribs. Starting slightly past the width of the shoulder on the right side, draw a pencil line from the outline of the umbrella through the dash-like pencil line to the top of the umbrella. The line should be straight with a slight bend. Don't make a line that is too arched as it won't look like an umbrella. The human brain knows there's an arch in umbrellas but not actually in the ribs of the umbrella. You'll create a small section at the top by doing this.

5 Repeat, but this time draw the line starting slightly past the width of the shoulder on the left side.

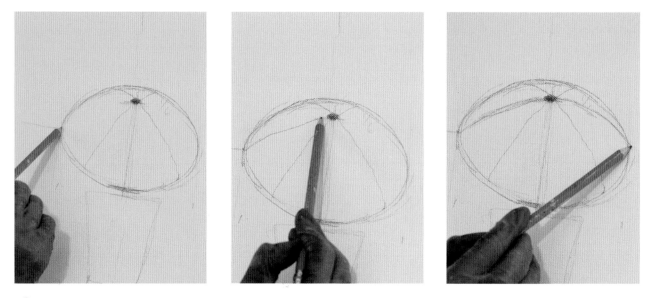

6 Draw a third line that is slightly arched starting from the center of the oval on the left side through the dash-like pencil line to the center of the right side of the oval.

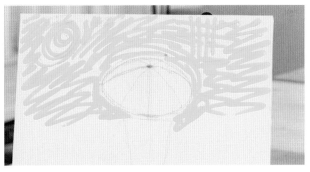

Paint the Background

Now that you're done with outlining, the fun, messy part begins. Put on your gloves and pick up Lemon Yellow. You're going to get piggish with it! Be wild and use it all up. Don't hold back. You're going to use the entire tube, or close to it. It's always a good idea to save a little bit for the sides, in case you choose to paint them.

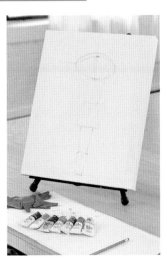

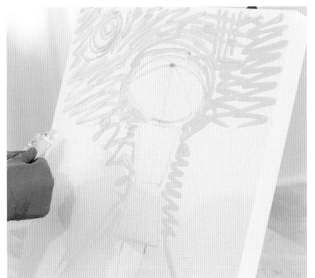

1 Using your thumb and index finger, apply the Yellow directly to the canvas. Start with filling in the space above the umbrella, outside of the girl. Make any shapes you want: circles, lines, zigzags—either way, you're going to fill in the white space, going right up to the pencil lines of the umbrella and the upper part of the girl's body.

2 Now start putting the Yellow paint on the center and bottom of the canvas. Begin near the right side of the girl's coat and work closely to its outline, being careful not to paint inside the girl's body. Once you reach the bottom of her coat, sweep the yellow line on an angle down to the right bottom of the canvas.

3 Repeat on the left side. Put big globs of the paint on the canvas; you're going to use your fingers to rub in the Yellow so we want a lot of paint to work with. To maximize your paint supply, press the tube against the edge of the table to push the paint from the bottom to the top of the tube like a toothpaste tube. Years of getting the most out of your toothpaste will really pay off here!

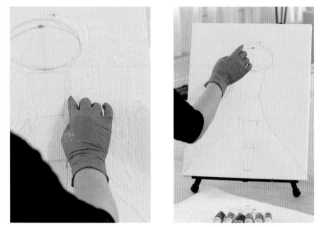

4 Starting from the top of the canvas, use your index, middle, and ring fingers to rub in all the Yellow paint—smoosh it right into the white space; it will create a beautiful texture. If need be, take globs from parts of the canvas and move them to where there is not much paint. You want a consistent textured coverage of the Yellow, but don't overthink it!

5 Go right up to the edges of the pencil lines, filling in Yellow down to the bottom of the canvas. Follow the angled path lines, leaving the inside of that space white—this is going to be the park path.

6 Once you're done, you'll have some extra paint on your fingers. Instead of wasting it, apply it to the side of the canvas at the top, coloring the edges. It doesn't have to be thick, just whatever is left on your fingers.

7 This step is about mindfulness. Enjoy this moment! After all, when was the last time you finger painted? This a form of art therapy, so remember to breathe and bring your attention to how nice the paint feels as you smoosh it around under your fingertips. Relax and let go. Don't think so much. Slow down and be in the present here. Be proud of the fact that you just used the entire tube of Yellow on the painting! This is an unusual level of painting gluttony, so own it. Do you think Van Gogh would have created *The Starry Night* if he had been fretting about using more than a little paint?

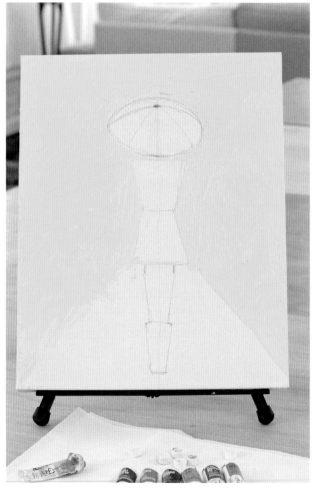

8 Now let's move down to the white path. With your pointer, middle, and index fingers, blend the Yellow paint slightly into the white path. You want to just smudge the yellow lines; go back and forth with your fingers to blend the paint into the white.

9 Use a paper towel to wipe the Yellow paint off and clean your fingers really well. Twist your fingers to remove as much paint as you can.

Paint the Umbrella

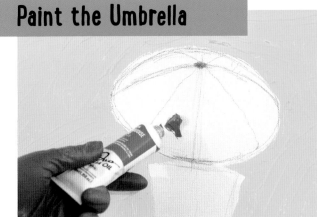

2 Fill in that slice with the turquoise. Push the paint around with your fingertips, staying within the lines of the segment. You're aiming for little ridges in your paint. The lighter you touch, the finer a point you can make with the paint. Pressing hard is not an advantage in finger painting.

1 Pick up Turquoise Blue; we're going to paint the ribs of the umbrella now. Squeeze a chickpea-sized amount of Blue onto the bottom-left segment of the umbrella.

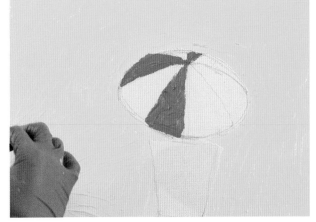

3 Reload your finger with turquoise. Skip a segment and then fill in the next one with turquoise.

4 Skip one again and fill in the small top segment with turquoise, using a pea-sized amount on your fingertip.

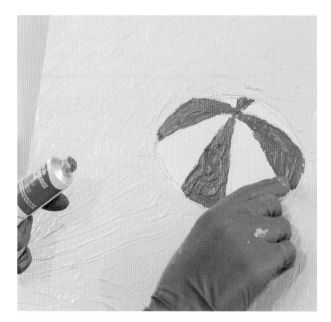

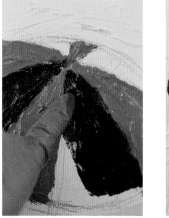

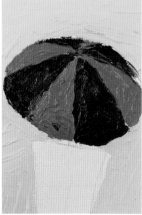

5 Reload your finger with paint and skip one more segment, filling in the last segment, on the right, with turquoise.

6 Pick up Cobalt Blue Hue. Place a chickpea-sized amount on your pointer finger and fill in all the white in the alternating segments. Go right up to the turquoise to create a smudge effect—a beautiful accident— at the edges with the two colors. Remember, the lighter you touch the better points you can get. The top segments are the hardest because they're the smallest, but cover the white space as best you can.

Create the Leaves

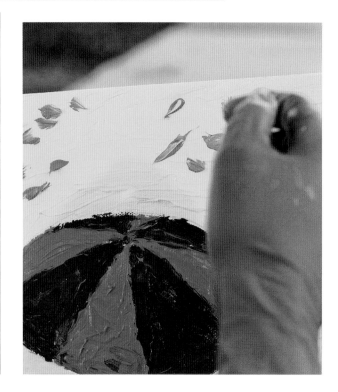

1 Clean your fingertips. Pick up Luminous Orange. This color has success written all over it! It's so bright and punchy. We're going to start creating leaves that will go all the way to the edges of the canvas and stop just above the umbrella. Place a chickpea-sized amount on your pointer finger and start dabbing above and around the umbrella with short, dash-like strokes on top of the Yellow paint. You should be able to get 10 dabs with that one chickpea-sized amount. Twist your finger with each dab to create a slightly different direction and texture.

2 As soon as you cover the Yellow with Orange, it's gone. So be mindful of the Yellow. Reload your finger with paint and continue dabbing the Yellow with the Orange. Clean the Yellow off your finger before dabbing again. Hold the paper towel in your hand so you can quickly dab while you work.

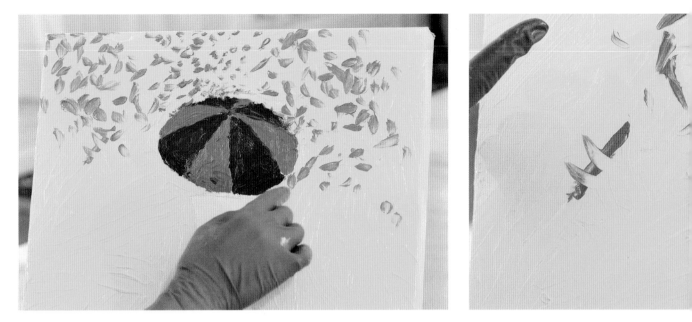

3 Grab some more Orange and continue, going right up to the edge of the umbrella. Stay away from long dabs. If you do create a long line, you can fix it by interrupting it by pushing yellow back over the top of it.

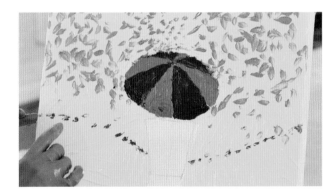

4 Pick up Naphthol Red. Place a pea-sized amount on your pointer finger and, starting at the height of the girl's left shoulder, create a sloping dotted line that extends from the edge of the canvas to right in between her waist and her shoulders. This is going to be the tree line. Repeat on the right side.

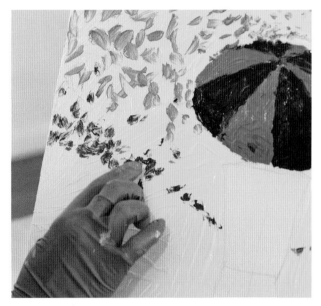

5 Place a pea-sized amount of Red on your pointer finger and dot just above the sloping lines to create a foggy collection of red dots along that tree line. Wipe your finger and repeat. Continue until you have a layer of red dots moving into the orange leaves.

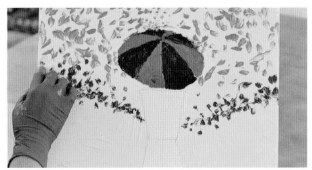

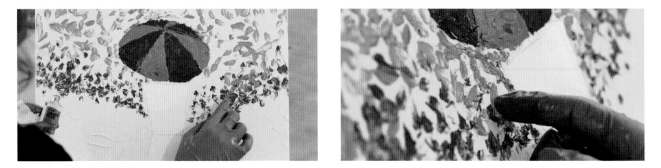

6 Pick up Luminous Orange again. Place a pea-sized amount on your pointer finger and dot the Orange into the red dots, cleaning your finger each time. Collide with the Red to create a new orange/red. Fill in more closely to the umbrella, all the way to the outline of the girl's coat. Your orange dots should be colliding with the Red and Yellow to create a beautiful spectrum of color.

7 Clean your fingers and pick up Naphthol Red again. We're going to create very loose dotted V-shapes in the orange leaf space following the slope of the tree line; these are going to be insinuations of tree branches. Do not make them linear, dragged lines. Create about 3 on each side, moving to the right when you're done with the left side. Make at least one on each side come up from the edges of the canvas, above the tree line, to insinuate branches in the farther trees in the distance.

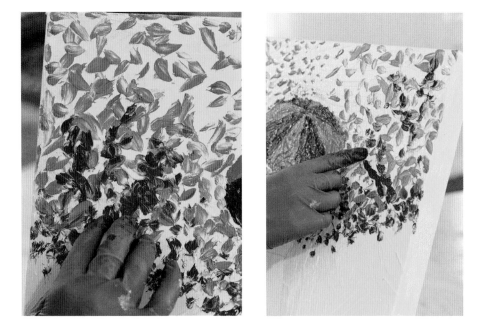

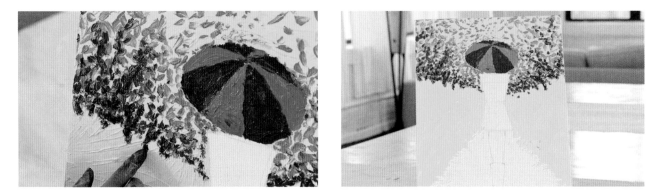

8 Clean your fingers and pick up Luminous Violet. Place a pea-sized amount on your pointer finger and create foggy V-shapes over the red tree line. If you can see a clear "V," it's too distinct; you want these to be abstract. Do 5 little mini Vs on each side along the tree line. These should be heading up, leaning slightly toward the middle.

Fill in the Path and Girl's Coat

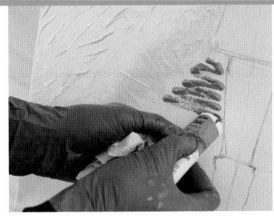

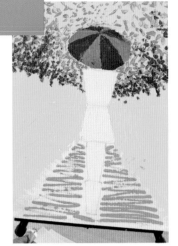

1 We're going to come back to the trees later. Clean your fingers and pick up the Lilac. With two hands, squeeze the tube and apply the Lilac directly onto the path. Apply in a zigzag horizontal pattern, being careful to avoid painting over the outline of the girl's legs and the Yellow on either side of the path. There should still be some white space in between the Yellow and Lilac.

2 Using your index finger, smear the Lilac paint to fill in the white space. Go right up to the yellow border and the pencil line. It will collide with the Yellow, which is okay. You might want to use two fingers in the larger space toward the bottom. Leave the border of the Lilac and the Yellow a bit jagged; try to avoid colliding the colors too much or making an exact border.

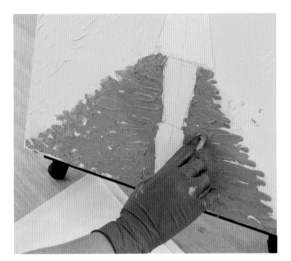

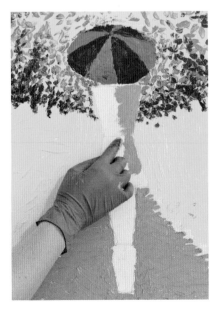

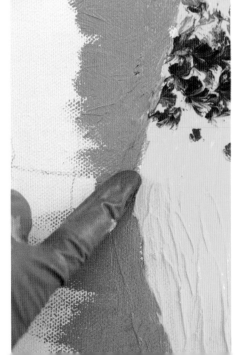

3 With the extra Lilac paint on your finger, fill in the right side of the girl's coat by doing small right-to-left strokes. Again, leave the edges jagged and not exact, and just fill in the Lilac on about one-third of her body on the right side, not going all the way to the middle. You can either reload Lilac on your finger or grab paint from the bottom of the canvas to finish outlining her coat.

4 Clean your hands. Pick up Cobalt Blue Hue and place a pea-sized amount on your fingertip. Draw a thick line along the left side of the girl's coat at the edge, along its outline. You will need to reload paint to continue down the girl's left side. At the bottom of the coat, drag the Blue in toward the center of her body just slightly.

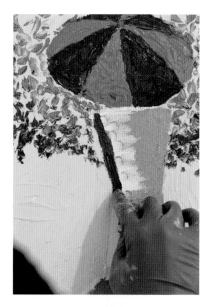
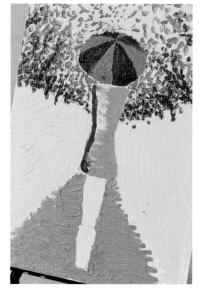

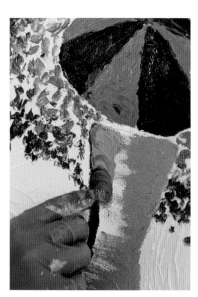

5 Clean your hands. Pick up Lilac again and apply a pea-sized amount on your pointer finger. Making small circular motions, blend the Lilac into the Cobalt Blue that you just put down in Step 4. Blend until you cover up all the white space inside the girl's coat. It's okay if the paint starts to mix here and wind up in other elements of the painting, such as traces of Blue from the girl's coat blending with the Yellow.

6 Pick up White and place a pea-sized amount on your fingertip. We are going to go over the Lilac on the right side of the girl's coat in a messy zigzag pattern, beginning at the top part of the coat coming all the way down its right side. Clean your finger, reload paint, and repeat as needed until you reach the bottom.

7 Starting in the bottom-right corner of the girl's coat, apply a large chunk of White, making a thick white swipe to the coat's left side.

Add More Detail to the Leaves and Path

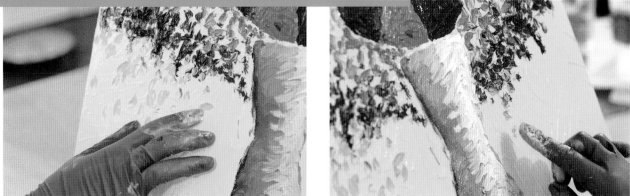

1 Pick up the Phthalo Green. Place a chickpea-sized amount on your fingertip and apply loose dabs and dots, starting at the red tree line and coming down into the Yellow. It's okay to contaminate your finger with the Red; just wipe your finger clean each time. Paint a few dabs up into the Red, above the tree line, then move right down past the tree line into the Yellow. The combination and collision of colors will give you a brownish red color, which is what we want!

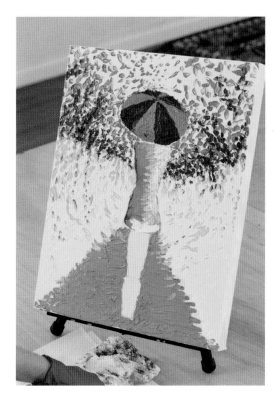

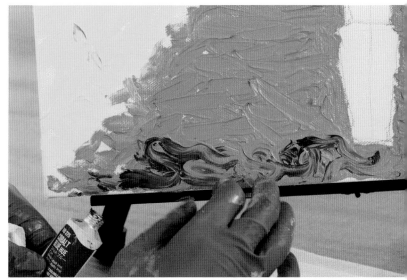

2 Continue to dab and dot the Green onto the canvas all the way down to the girl's legs, following an arching pattern inward toward the park path. This is going to create a larger circular pattern for the whole painting.

3 Clean your fingers and pick up the Cobalt Blue Hue. This is a strong color, so a little goes a long way. Starting with the bottom-left side of the canvas in the purple park path, use your pointer and middle fingers to paint several short horizontal smeary, squiggly lines into the purple path. Use a very light touch, and don't go over and over your lines. We want to just lightly touch the Lilac. The lines at the bottom of the canvas should be thicker than at the middle and top part of the path. Go right up to the pencil line of her boots. The squiggly lines almost look like waves or moving water. Clean your fingers and reload paint as needed.

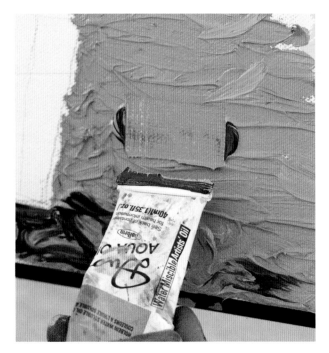

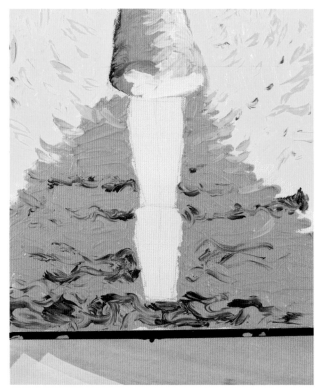

4 If you feel like you're added too much Blue, simply use the bottom of the paint tube to scrape off the Blue and start over. Go over the paint just once, with a fairly light touch, to remove the Blue. If you scrape too hard you'll remove the Lilac too, which we don't want to do.

5 Continue to make a few horizontal squiggly lines up the path, alternating the location so they are not symmetrical, and stop right above the girl's boot line.

Paint the Girl's Clothing

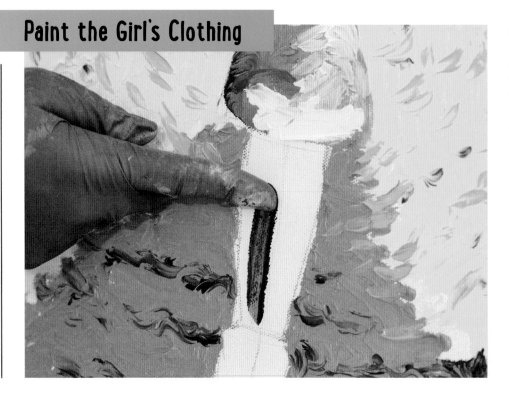

1 Clean your fingers. Reload a pea-sized amount of Blue onto your fingertip and swipe a thick vertical line from the bottom marker (where the girl's boots meet her legs) up to the coat base.

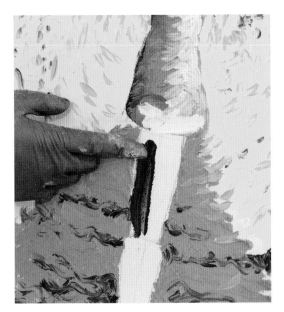

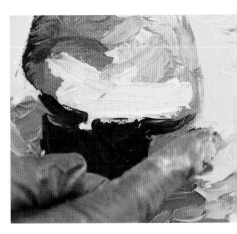

3 Clean your fingers and reload Cobalt Blue Hue on your fingertip. We're going to create a shadow under her coat by painting a slightly arched line that follows her coat's shape. Moving right to left, drag the Blue lightly along the base of her coat underneath the White and stop just past where her legs meet the coat base.

2 Repeat until the white space of her legs is filled in with Blue, being mindful not to go over it too much. Use long swipes in one direction, trying not to go back over your paint in the opposite direction.

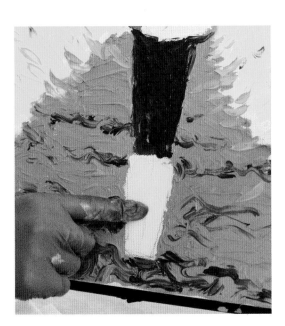

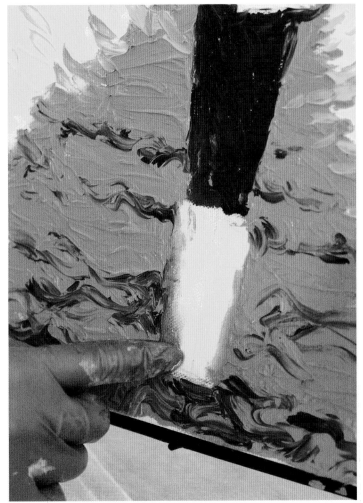

4 Clean your fingers. We're going to color in her boots now by grabbing any extra Yellow you can find on the canvas. With your pointer finger, take Yellow from any part of the canvas (we call this "mining" for color) and begin coloring in the boots.

5 Clean your fingers very well each time. Fill in all the white space with the Yellow. When the Yellow hits the Purple in the path, it will create a nice shadowy color.

6 Let's go back to the coat now and add in more Lilac. Clean your fingers and pick up the Lilac. Place a pea-sized amount on your fingertip and create a few large zigzag lines on an angle coming from the left edge of her coat into the center.

7 It looks like I need more White on the right side of the girl's coat to give it more of a definitive highlight. I'm cleaning my fingers and placing a pea-sized amount on my fingertip and adding a small swipe to the right corner of her coat bottom, outlining that corner.

8 Clean your fingers and grab a dab of Luminous Violet from the park path. With the purple, draw a loose straight line down the center of the girl's pants. It will be very faint and give just the slightest suggestion of legs. Bring the line down in one movement, down to the top of her boots.

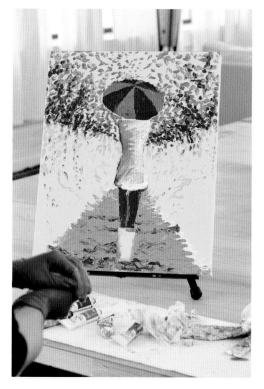

9 Clean your fingers. We're going to define the top of the boots by grabbing some Luminous Orange from the leaves at the top of the canvas and swiping from the top-right boot edge into the center, stopping there. This should be a faded line.

10 Step back and check out your painting so far. It's really starting to come together! Remember, yours doesn't need to look as exact as mine. Your strokes may vary slightly and you may get a slight variation of colors, but the general look of the painting should be similar to mine.

Add the Tree Trunks

1 Now let's paint in the tree trunks along the tree line. Pick up Naphthol Red and place a chickpea-sized amount on your pointer finger. Starting from the left edge of the canvas, draw a dabbed dotted line from the tree line down the canvas, stopping at about where the girl's knees are. The strokes should be more like longer dabs than dots; keep the touch fairly light. Clean your fingers and reload paint as needed.

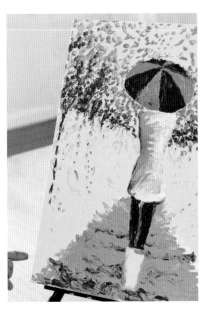

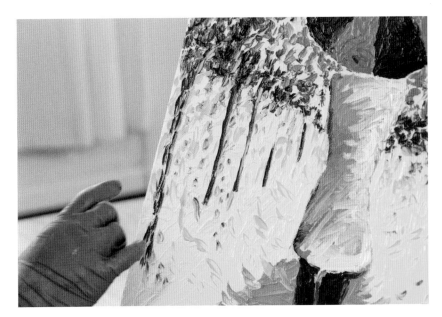

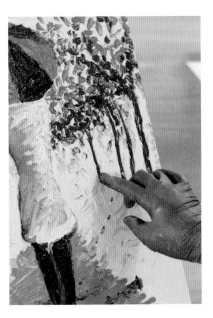

2 Repeat, moving into the center of the painting. As you move closer to the center, the trunks should get shorter and the lines of the trunks should get skinnier. As you move closer to the girl's figure, the bottom of the trunks should stop farther up her body to give the illusion that the trees in the back are in the distance. Move to the right side of the canvas and repeat. You should have about 5 tree trunks on each side. Try not to be too symmetrical.

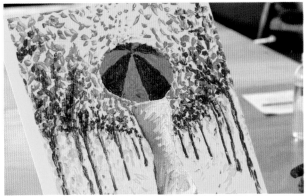

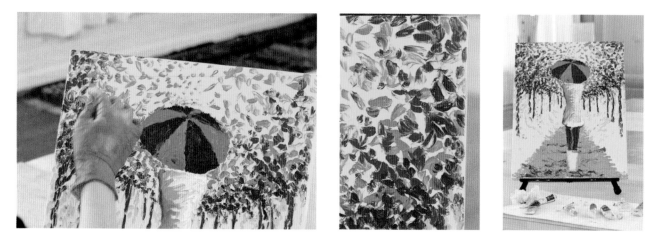

3 Now that we have the structure of the trees, let's move up to the leaves and fill in more colors. Clean your fingers and pick up Luminous Violet. Place a chickpea-sized amount on your pointer finger. Beginning with the top-left part of the canvas, dab it into the existing leaves and colors, cleaning your fingers and reloading paint as needed. Stick close to the top-right and -left sides of the canvas, staying away from the center. This will add dimension to the painting, giving the illusion of shadow and depth.

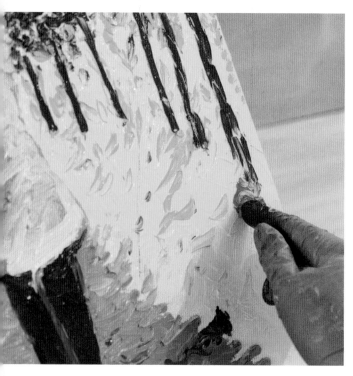

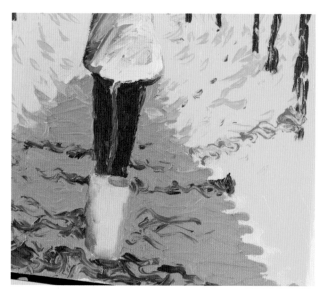

4 Clean your fingers and pick up Turquoise Blue. We're going to create more dimension in the grass at the bottom of the canvas. Place a chickpea-sized amount on your pointer finger and, starting from the right side, make a squiggly zigzag line on a slight slope, coming from the bottom of the first tree trunk and continuing into the path. Wipe your fingers and repeat on the other side.

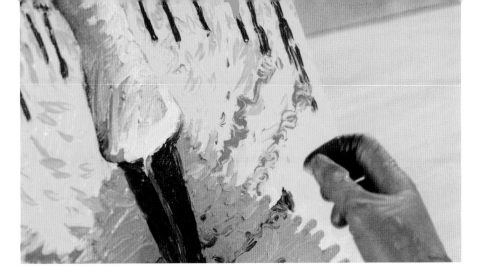

5 Use a gentle downward motion to continue these lines, originating from the bottom of each tree trunk into the park path.

6 You can also create a few lines behind the trees, as I've done here on the right side of the painting.

7 Add a few of the same short squiggly lines to the bottom yellow part of the painting on either side of the path. You should have around five of the longer squiggly lines on each side and two or three of the shorter ones.

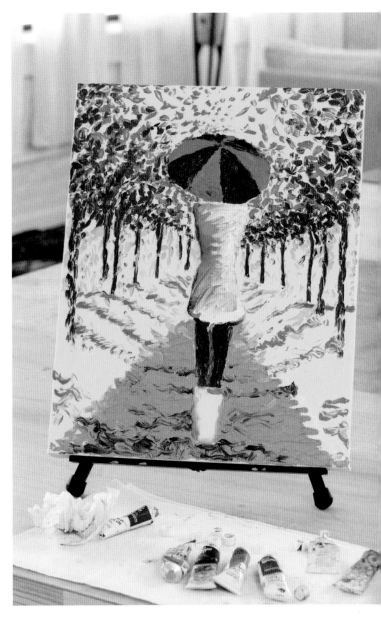

Finish the Path

1 Now we're going to work at the bottom of the painting to blend the Lilac of the path into the Yellow outside the path and blend the scenery. Clean your fingers and use your pointer finger to bring the Yellow into the border of the path, combining the colors. Stop each time you pull the Yellow into the Lilac, then clean your fingers and repeat. Clean your fingers every time you blend colors, being mindful not to move back and forth too much. Remember, we don't want to over-touch the painting! Also blend the Lilac into the Blue from Step 3 (Add More Detail to Leaves and Path, page 83) into the Yellow, creating a greenish color in the path.

2 Move up the path on both sides to blend the Lilac border of the path into the Yellow and Blue. Work side to side, inching up the canvas. Never make up and down strokes here!

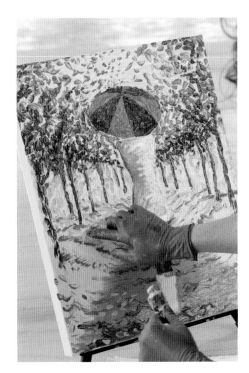

3 Clean your fingers and pick up the Yellow Green. Place a chickpea-sized amount on your fingertip and dab it into the Lilac path. Start at the bottom of the path on the edges, cleaning your finger each time you run out of paint, then reloading and repeating. Keep a really light touch with the Yellow Green because we want to keep it on top of the Lilac; we don't want it to blend in too much. Also dab the Yellow Green into the Blue at the bottom of the path to lighten it up.

4 Once you're done adding some Yellow Green into the path, move to the tree trunks in the back of the painting and paint short little Yellow Green lines in between the tree trunks, in between the Blue from Step 4 (Add the Tree Trunks, page 86), coming from the bottom of the trunks and into the path. Clean your fingers each time you run out of paint, and reload and repeat as needed, creating these lines along the tree trunks in the back half of the painting.

Add Details to the Girl

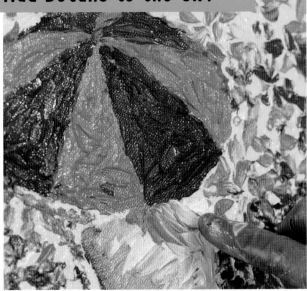

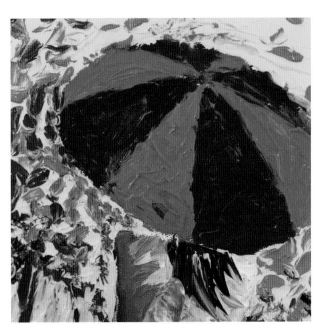

1 Clean your fingers, pick up Luminous Orange, and place a chickpea-sized amount on your fingertip. Apply small wispy strokes from the bottom of the umbrella onto her shoulders. You want a slight curve to the line so it looks like her hair is blowing to the right. You want to touch just a few times; don't overdo the hair or the colors will blend too much.

2 Clean your fingers. Pick up Luminous Violet and repeat the same small wispy strokes over the Orange, making them shorter than the orange strokes. The orange strokes should peek out behind the purple wisps. Use a very light touch.

3 Clean your fingers and pick up Cobalt Blue Hue. Place a chickpea-sized amount on your pointer fingertip and reinforce the border between the bottom of the umbrella and the girl's shoulders by running one chunky stroke along the border. Then use the Blue to paint shorter wisps in the hair on top of the purple.

4 Clean your fingers. Pick up a tiny dot of Luminous Violet on your pointer finger from the leaves at the top part of the canvas. Move down to the girl's left boot and fill in the left boot with a light layer of purple, leaving a small yellow border from the existing color. The line should be thicker at the top and thinning as it goes down, creating a cone shape.

5 Clean your fingers. Pick up a dot of Luminous Orange from the right side of the boot and rub it into the dark purple at the top left of the boot. Don't go back into the Orange with the dark purple.

6 Clean your fingers and grab Naphthol Red from the top part of the canvas and dab at the bottom of the right boot, moving back and forth with a light touch once or twice to blend lightly. Use a small amount and don't over-touch it. If you end up with too much Red, just clean your fingers, take some Yellow, and pull it back over the Red.

Finish the Trees

1 Clean your fingers. Pick up Turquoise Blue. Starting with the innermost tree trunk in the back of the canvas on the left side, paint very light loose lines from the top of the leaves to the base of the trunk, working in between the trunks. We're going to add these blue lines only to the back half of the trunks to allude to the darkness of the trees that are farther away, so stop when you reach the halfway point.

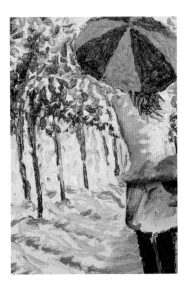

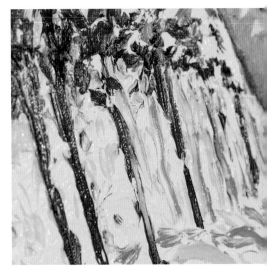

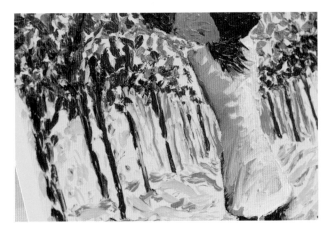

2 Repeat Step 1 on the right side. Wipe your fingers each time.

3 Clean your fingers. We're going to paint the shadow of the tree trunks now. Place a chickpea-sized amount of Luminous Violet on your fingertip and, starting with the outermost tree on the left side of the canvas, run the dark purple in a disjointed line from the leaves to the bottom of the trunk. The line should be next to the tree trunk, not directly on top of it, since the light source is in the middle of the painting. Repeat for the next two trees.

4 If you make too large a trunk or too thick a line, you can easily fix this by taking the bottom of the paint tube and scraping the paint off the canvas. Make sure to add the turquoise squiggly lines back in between the trees if you scrape this off.

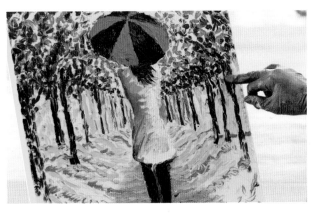

5 Repeat Step 3 on the right side.

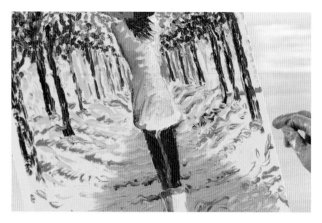

6 Clean your fingers. With the Luminous Violet, add squiggly lines in a few places over the blue squiggly lines from Step 4 (Add the Tree Trunks, page 86). This will create a nice shadow.

7 Clean your fingers. Pick up Luminous Orange and make small, suggestive, vertical lines in between the tree trunks in the back half (the ones in the distance) on the left side of the painting, over the blue lines, next to the purple lines. Repeat on the right side.

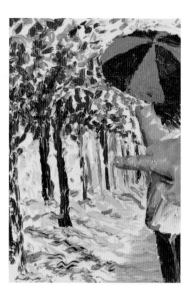

Finish the Umbrella

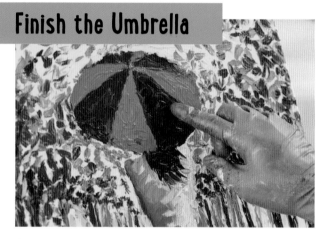

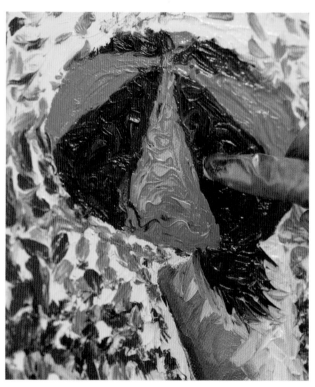

1 Clean your fingers and pick up Luminous Violet. Place a pea-sized amount on your fingertip and smear it into one of the dark-blue sections of the umbrella top using a squiggly-line motion, moving in different directions. Use a very light touch and repeat in the remaining 3 dark-blue sections.

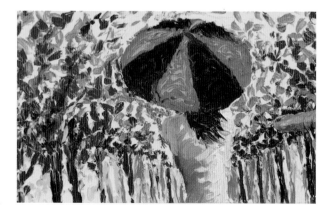

2 Clean your fingers and pick up Lilac. Place a pea-sized amount on your fingertip and smear it into the 4 light-blue sections in a squiggly-line motion with a light touch.

3 Here's what your umbrella should look like.

Finish Painting the Girl

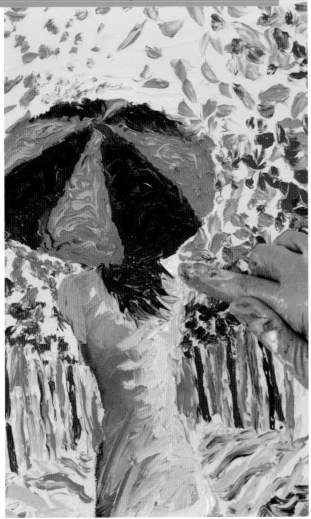

2 If the girl is looking too thin and narrow, move back over the blue line running down the left side of her coat to soften her outline.

1 Clean your fingers and pick up Luminous Violet. We're going to round out the girl's shoulders by taking the paint and creating small, round circular motions at the top of her shoulders.

3 Clean your fingers. Pick up Luminous Violet and place a pea-sized amount on your pointer finger. Run small lines in the center of the legs to create a darker accent. They should be wispy and light, not bold or sharp.

4 Clean your fingers and run one thick short line of Luminous Violet horizontally through the center of the base of her coat to add a darker highlight here, too.

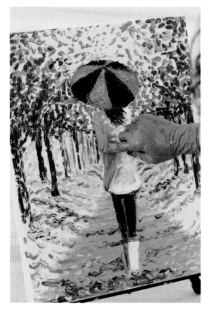

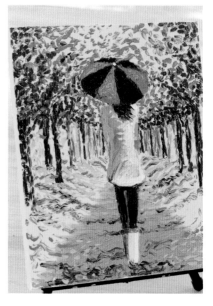

5 To give the girl tucked elbows, as if she's holding the umbrella like a bouquet of flowers, pick up Lilac and run a solid line down from the bottom of her shoulder to just above her waist on her left side. Repeat on her right side.

6 Clean your fingers and pick up White. Place a pea-sized amount on your pointer finger and run a vertical white line down the right edge of the right boot. It should be one long swipe from the top of the boot to the bottom; do not go back up over the paint—it won't be White!

7 Clean your fingers and place a pea-sized amount on your pointer finger. Dot the center of the umbrella with the White.

Paint the Falling Leaves

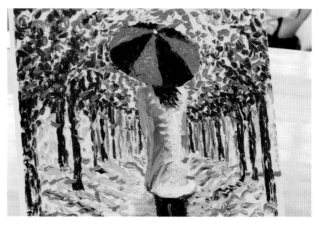

1 Clean your fingers and pick up Luminous Orange. Place a chickpea-sized amount on your fingertip. We're going to go a little crazy! Starting on the right side of the umbrella, dab the Orange on top of the light-blue quadrant of the umbrella. Use only one stroke; do not go back and forth—it's a bit like a flicking motion. Keep the leaves moving horizontally, not vertically. This will create the illusion that the leaves are falling naturally, as leaves don't usually fall straight down vertically.

2 Clean your fingers each time and reload the Orange on your finger. You should get 3–4 dabs with each load of paint, but you may need to reload after 1 or 2 dabs. Add more orange dabs at the top of the painting and also over the tree trunks. Do a couple over the girl's coat and a few on the path. Make some larger than others and some clustered together as if they've fallen on the ground in a pile. Do not create a pattern; we want to achieve randomness here. Clean your fingers each time.

3 Clean your fingers and pick up Lilac. Place a chickpea-sized amount on your fingertip and do the same dabbing motion as in Step 1 to create the lilac leaves near the orange leaves. It's okay if they collide a bit; we want it to look as natural as possible. Continue dabbing lilac leaves into the sky, over the existing orange red, and yellow colors, cleaning your fingers each time. Step back and look at your painting from afar and you'll know when you have enough leaves.

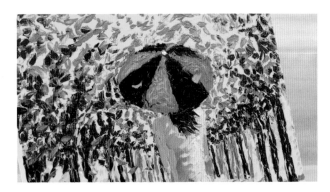

4 Let's give the girl a belt to make her waist a bit more defined. Make sure your fingers are clean and, with your pointer finger, take a small amount of dark-blue paint (Cobalt Blue Hue) from one of the umbrella quadrants. In a single long stroke, paint a slightly arched line from the left to the right side of her body.

5 Clean your fingers and take a small amount of the Turquoise Blue from the umbrella. Using the same motion as Step 1, highlight the Cobalt Blue with the Turquoise Blue by running one long stroke from left to right over the dark blue paint.

6 Clean your fingers and pick up Naphthol Red. Place a chickpea-sized amount on your fingertip and repeat the same dabbing stroke as in Step 1 (Paint the Falling Leaves, page 96). Choose a few orange leaves and go directly over them with the Red.

7 Clean your fingers and pick up Turquoise Blue. Place a chickpea-sized amount on your fingertip and make small dabs on top of the existing red leaves that we made in Step 7 (Create the Leaves, page 80). Add the dabs in a loose arching pattern inward toward the umbrella, cleaning your finger each time and reloading the paint as needed.

8 Clean your fingers and repeat with the Yellow Green, placing green leaves on top of the Red and even a little into the Yellow at the top of the painting. If you see a big block of Red, that's a good place to add green leaves. If you see any other color blocks, add in leaves in a contrasting color.

Now is a good time to step back and look at your painting. Take a picture with your phone and send it to a friend. Take a break for 5 minutes, then come back and you may notice different areas that need more leaves, more highlighting, or some other adjusting. Remember, this is impressionistic so nothing should look too defined! You don't want to touch the painting too much.

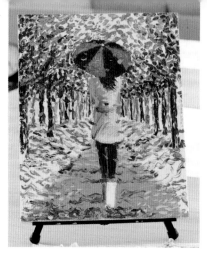

Make the Finishing Touches

1 The park path is looking a little one-dimensional to me, so let's add more shadow. Clean your fingers and pick up the Luminous Violet. Place a pea-sized amount on your fingertip and paint thick squiggly lines over the path into the landscape.

2 Now is the time to add any last-minute highlights to your painting. Lilac is great for highlighting trees, so add in some loose vertical lines in between the trees in the front half of the painting.

3 Add a few more orange leaves on top of white leaves to give the illusion of closer leaves in the front of the painting. With clean fingers, pick up the White and place a pea-sized amount on your fingertip. Paint 8–10 leaf dabs around the painting; most should be chunky but some can be smaller than others. Resist the temptation to balance everything; we're going for a very loose, almost random horizontal pattern of leaves.

4 Clean your fingers and pick up Luminous Orange. Place a chickpea-sized amount on your fingertip and apply strokes directly over all the white dabs. Use a bit more Orange than White to cover up the White for the most part. You want to try and cover up the White as much as you can. Always remember to clean your fingertips before you take Orange from the tube.

5 If you are going to frame your painting, you don't need to paint the edges; if you're not going to frame it, paint all four sides by wrapping the painting around the sides of the canvas. Let your painting dry for 3–4 weeks. Screw in a wire for hanging to the back of this beautiful painting and it will be a great addition to any décor!

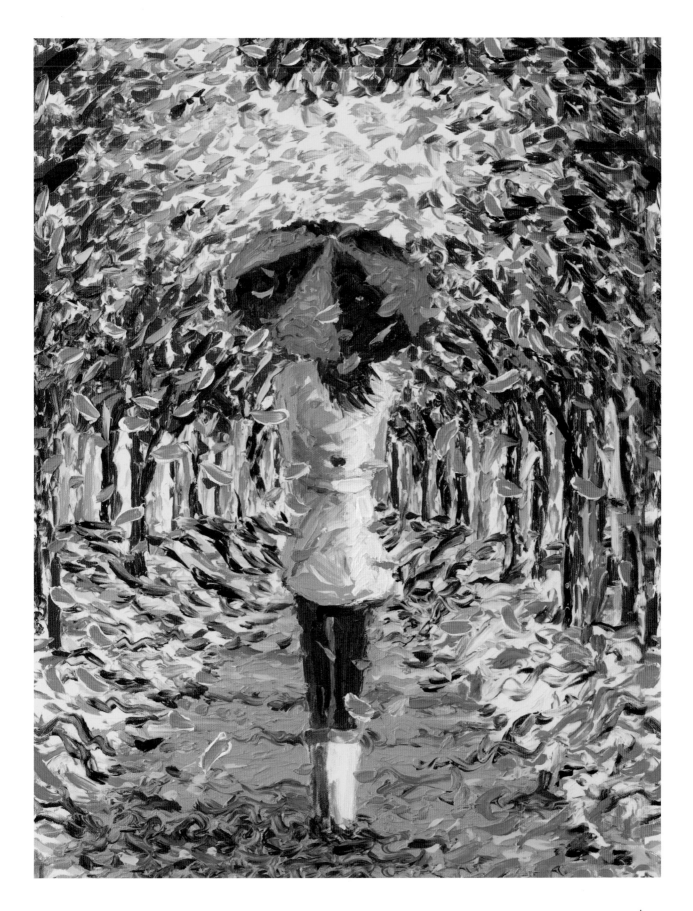

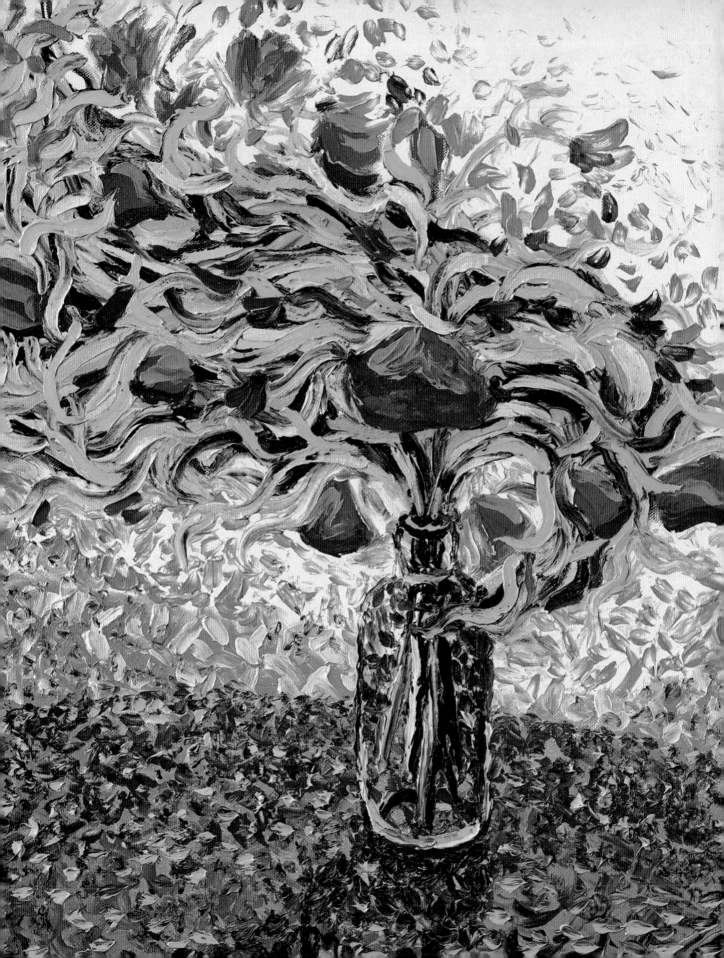

RED FLORAL

Some people look at this painting and see floppy poppies; others see roses. The little antique glass pop bottle, which forms the vase here, was something I happened upon in a little antique store in Virginia. Regardless of the flower and vase that you see, this floral composition is meant to look surrealist and stylized. I love to occasionally paint a vase of flowers because it is such a forgiving subject.

This painting utilizes my "weaving" technique, in which you push and pull the paint over itself like a wicker basket. It is also easy to change colors and shapes to get dramatically different results. As you embark on this painting it's important to not skimp on the paint. Constantly clean your fingertips whenever they're contaminated with a color that you don't want. I hope you enjoy bright colors, because this painting is about being bold and seeing the world through "finger-painted-colored" glasses. Let's get started!

MATERIALS

TOTAL PAINT
AND PREP
TIME:
4–6 HOURS
(TO BE DONE IN
ONE SITTING)

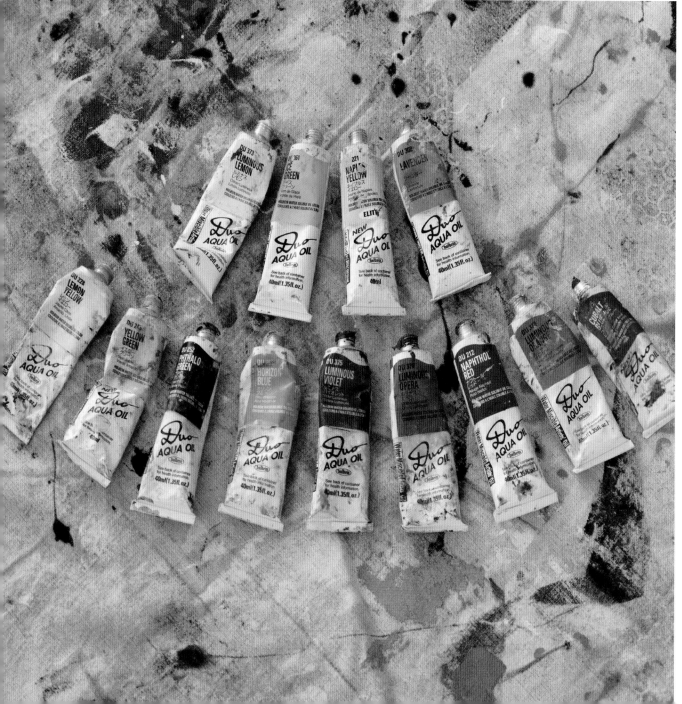

What You'll Need: latex gloves; 16 x 20-inch (41 x 51 cm) canvas; easel; roll of paper towels

13 oil colors: Luminous Lemon, Lemon Yellow, Naples Yellow, Yellow Green, Ice Green, Phthalo Green, Horizon Blue, Cobalt Blue Hue, Luminous Violet, Luminous Opera, Luminous Orange, Naphthol Red, Lavender

▲ Set up your canvas vertically on your easel and place your roll of paper towels close by. Put on your gloves and remove all the paint caps.

Outline the Greenery

1 Pick up Phthalo Green. Place a chickpea-sized amount on your pointer fingertip and dot the canvas in the upper-left corner.

2 Reload your finger with paint. Make another dot halfway down the canvas on the left side.

3 Reload your finger with paint and draw a faint line across the center of the canvas. You may need to reload again to get all the way across.

4 Reload your finger with paint and, in the center of the canvas, make a cross by drawing a short vertical line through the horizontal line. The lighter you draw with your fingertip, the farther the paint will go.

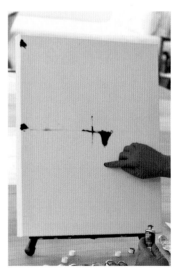

5 Reload your finger with paint and create an inverted triangle to the right of the center of the cross. Fill the triangle in with paint.

6 Reload your finger with paint and make a dot about 2 inches (5 cm) below the triangle point.

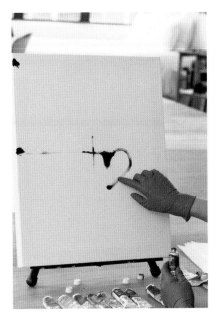

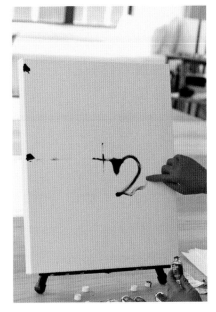

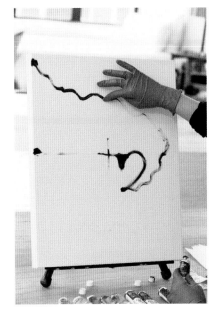

7 Reload your finger with paint and connect the top right of the triangle to the dot with a half heart–shaped, arched line.

8 Reload your finger with paint. From the dot below the triangle, paint a loose squiggly line coming out to the right of the dot, then moving up and around to the left side of the canvas, ending at the top-left dot.

9 Reload your finger with paint and go back over the green squiggly line where it looks faint.

10 From the dot on the left side halfway down the canvas, create a wave pattern (some large, some small) connecting to the top-left side of the triangle.

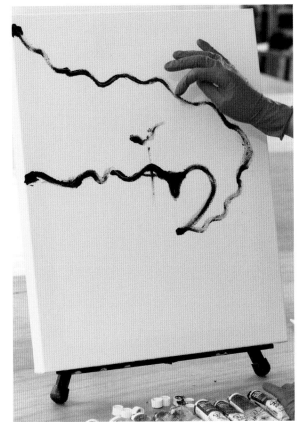

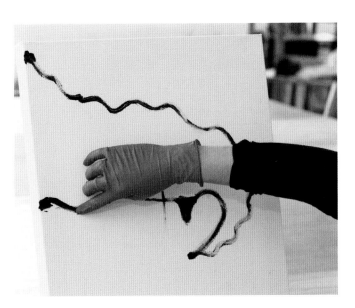

11 If you have any extra paint on your fingertip, place it above the triangle in the green outline you just created; we're going to need it later.

Block Out the Flower Placement

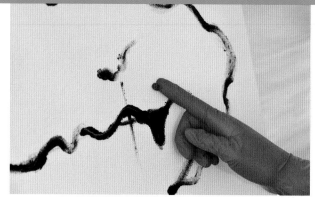

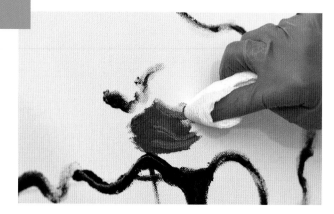

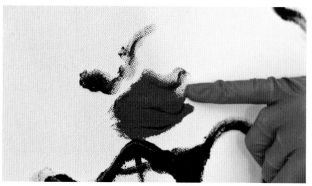

1 Clean your fingers and pick up Luminous Opera. Place a chickpea-sized amount on your pointer fingertip and then place a big blob just above and to the left of the triangle.

2 If you still have any Green paint on your fingers, it will contaminate the Luminous Opera. You can fix this by wrapping a paper towel around the top of your pointer fingers and wiping the Green out of the pink.

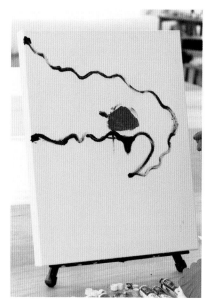

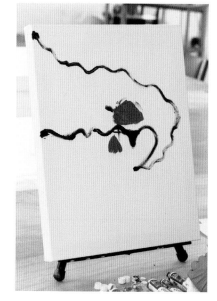

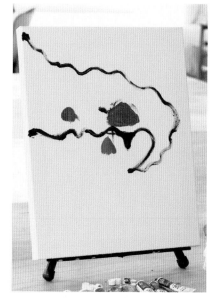

3 Once you've wiped away the Green, continue making a loose bell shape with Luminous Opera. We're going to paint a number of these "bells" (13 total), and each one will vary slightly in size and shape.

4 Make a second, smaller bell outside of the green outline right below and to the left of the first bell.

5 Place a third bell inside the green outline to the left of the first bell by about 3–4 inches (7.5–10 cm). Make this one a more circular shape.

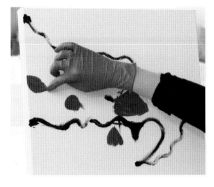

6 Place a fourth bell above and to the left of the third bell. Make this one into the shape of lips.

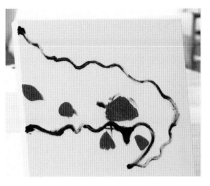

7 Place a fifth bell in between the nook of the green triangle and the half-heart shape. Make this one into a roundish triangle shape, with the point facing upward and left.

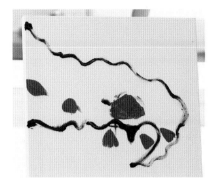

8 Place a sixth bell—the same size and shape as the fifth bell—in the middle of the green band to the right of the fifth bell.

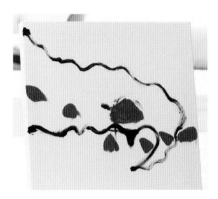

9 Place a seventh bell to the right of the sixth one, just outside of the green outline. Make this a rounded rectangular shape.

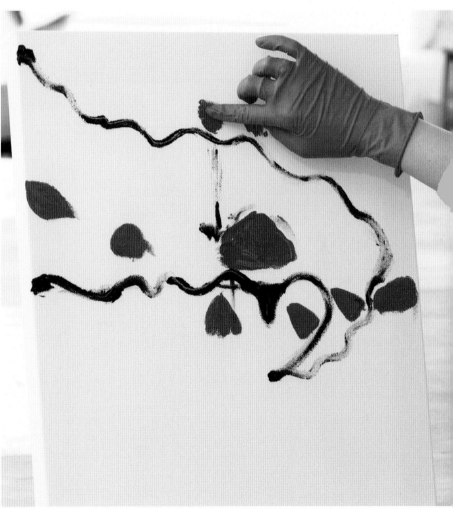

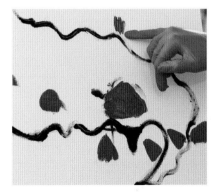

10 Place an eighth bell right above the first bell we made in Step 3, outside of the green boundary. Instead of a triangle shape, make a series of 3 vertical swipes right next to each other.

11 Place a ninth bell to the left of the eighth one, in a small, rounded triangular shape.

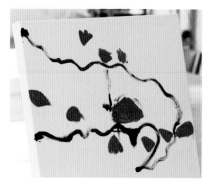

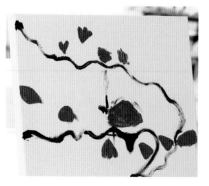

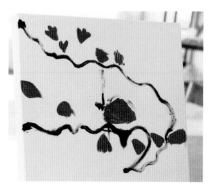

12 To the left and above the ninth bell, place the tenth one in a fan pattern. Use a similar stroke as in Step 10 but a bit larger and more defined—it's 3 vertical strokes that meet at the bottom of each stroke, like a flower. Texture is your friend!

15 Below the twelfth one, inside the green boundary, make the thirteenth (and final) bell with a fan pattern, like in Steps 12 and 14, but turned counterclockwise so it's facing west.

13 Almost done with the flowers; just a few more bells to add. Place an eleventh bell to the left and below the tenth one, in a small V pattern.

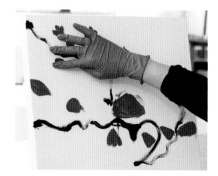

14 Above and left of the eleventh one, place the twelfth bell in a fan pattern, like in Step 12.

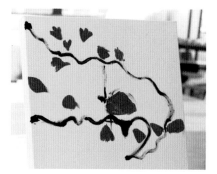

Paint the Upper Background

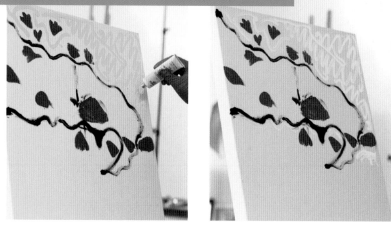

1 Clean your fingers and pick up Luminous Lemon. Take the tube between your thumb and pointer fingers and apply it directly on the canvas, starting in the upper-right corner. Apply it in between the green lines and the flowers, avoiding the flowers. Keep applying the Yellow all around the top of the painting (and a small amount below the flower on the right edge of the canvas) on the bottom of the green outline, then stop.

2 It's important to have very clean hands now, so wipe them well. Using your fingertip, begin filling in the Yellow, leaving space around the flowers. You can use two fingers to carefully push the color into the white canvas. Try not to contaminate the Green. If you do, clean your fingers and keep blending the Yellow into the canvas.

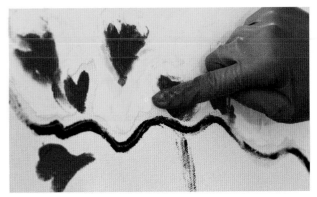

3 Clean your fingers. Now we're going to push the Yellow into the pink (Luminous Opera) flowers. Using your pointer finger, push the Yellow into the edges of the pink flowers; don't push the Pink back into the Yellow. Clean your fingers and repeat. You do want a few color collisions (I call them happy accidents), but not too many. You'll see the colors along the edges of the flowers start to bleed. This "bleeding" effect is cool because it simulates realism simply by default. It is one of my favorite finger-painting "accidents."

4 If you find you need more Yellow, grab it from other areas of the painting with clean fingers or apply more on the canvas from the tube. (Make sure the tube isn't contaminated with any other colors. My tube had Green on it so now I have some Green in my Yellow, which is okay—a happy accident!) Continue pushing Yellow into the Pink, cleaning and repeating through all the flowers at the top of the painting. If the tube is contaminated, simply wipe it off with a paper towel, then squeeze the tube just enough for a little Yellow to come out, to really get things back to a sharp clean yellow.

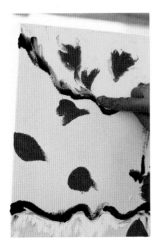

5 Clean your fingers. Now we're going to push the Yellow into the Green; really clean your fingers after each push, to remove the Green. You may need more Yellow. You'll see that the Green is bleeding into the Yellow, but I'm not actually pulling it back into the Yellow; this will happen without doing that because this Green is a very powerful color.

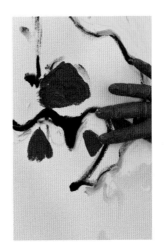

6 Clean your fingers well and push the Yellow into the pink of the flowers on the right side of the canvas as well as the ones below the bottom green boundary.

7 Continue pushing the Yellow into the green boundary on the bottom and right, adding more Yellow to the canvas as needed and cleaning your fingers each time.

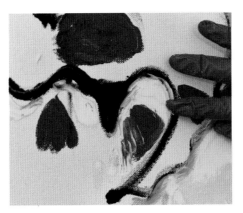

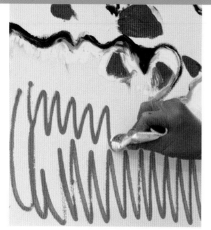

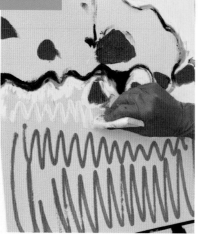

1 Clean your fingers and pick up Luminous Orange; we're going to fill in the bottom part of the canvas. This is another delicious color! Place the tube in between your pointer finger and your thumb, and apply directly onto the canvas using large vertical squiggly patterns. Don't go all the way to the bottom of the green boundary; we are going to place a band of Yellow here.

2 Pick up Luminous Yellow. Fill in the band directly underneath the green boundary with the Yellow in a smaller vertical squiggly-line pattern.

3 Using 2 or 3 fingers, begin coloring in the orange areas of the canvas with the Orange paint. I realize I didn't put enough on my canvas, so I need to add a blob. If you're not using enough paint, your fingers will scrape the canvas and you'll hear a scratching noise as they run along the canvas, so add more if you need to. When you're using enough paint, the oil should glide across the canvas and collide smoothly with the other colors.

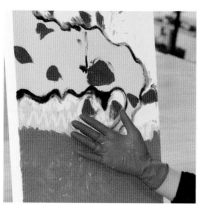

4 Cover the entire bottom of the canvas with Orange, then clean your fingers well. Orange is one of those colors that doesn't need to be painted on super-thick; in fact, it's prettier when it's medium-thick because it's so transparent that the canvas will sparkle through it.

5 With very clean fingers, use a circular motion to fill the lower canvas with the Yellow, covering all of the white in the area. Go right up to the Orange; the borders will blend. You may even pull some of the Green into the Yellow, which is okay.

6 Clean your fingers and pick up Luminous Opera. Dot
 your pointer, middle, and ring fingers with a dab of
pink on each. Beginning at the bottom left of the canvas,
paint a series of short squiggly patterns with all three
fingers with a very light touch. Let the paint trail off.

7 Clean your fingers each time and continue the pattern
 all over the solid orange space, stopping a few inches
(approximately 7.5 cm) from the right side of the canvas.

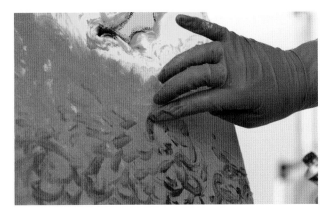

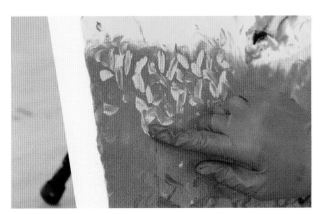

8 Pick up Luminous Opera and repeat the same short
 squiggly pattern, from bottom to top, starting at the
end of the pink squiggly patterns on the right side of the
canvas. Let the paint trail off. Contain the purple squiggly
lines to the bottom-right corner to meet the pink.

9 Clean your fingers and pick up Lemon Yellow. Place a
 chickpea-sized amount on your pointer fingertip and,
with a very light touch, make single dabs in a crisscross
pattern onto the left side of the canvas into the solid
Orange paint. Dab left to right and up to down, staying
just on the left side of the canvas for now. Clean your
fingers each time and reload paint after a few strokes. You
should be able to get 6–7 dabs with each paint amount.

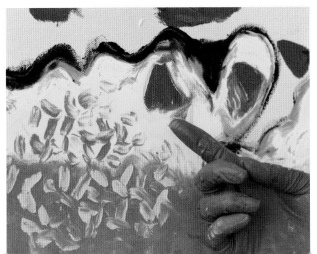

10 Clean your fingers and pick up Luminous Orange.
 Using the same crisscross pattern, dab the Orange
into the solid Yellow paint above the solid Orange paint.
The goal is to make the border between the Orange and
the Yellow foggy.

11 Clean your fingers. Now we're going to dab Orange into the solid Yellow on the right side of the canvas. Place a chickpea-sized amount on your pointer fingertip and dab it into the Yellow, filling the whole yellow space.

12 Continue dabbing in the same pattern to the left until you reach the crisscross patterns you created in Step 10. Dab right up to the green border with Orange. Break up that solid yellow zone!

14 Now we're going to create the line of the table with Naphthol Red. From the left edge of the canvas about one-quarter of the way up, draw a loose line that curves slightly down to the right side of the canvas. The red dabs from Step 13 should be below this table line.

13 Clean your fingers and pick up Naphthol Red. Place a chickpea-sized amount on your pointer fingertip. Make small dabs/wisps in the central-right part of the solid Orange, partially over the pink (Luminous Opera) squiggly lines. Once you cover the Orange, it's gone forever, so don't overdo it. Continue dabbing into the Orange with the Red in a larger crisscross pattern. Dab over to the left side of the canvas, almost up to the yellow dabs, cleaning your finger and reloading paint as needed.

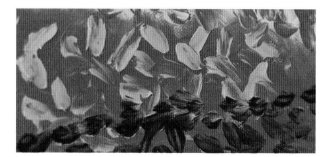

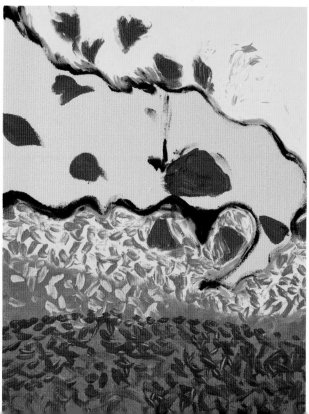

15 Here's a close-up so you can see the texture, direction, and shape of my dabs.

16 Clean your fingers and pick up Lemon Yellow. Place a chickpea-sized amount on your pointer fingertip and make single dabs into the solid Orange paint above the table line, filling in any spots that are still predominately Orange. Blocks of one color should always be broken up.

17 The line between the yellow and orange bands of color need to be more discreet, so pick up Luminous Orange again and fill in over that line with clustered dabs to blend the line and make it less obvious. Clean your fingers and reload paint as needed.

Continue Painting the Greenery

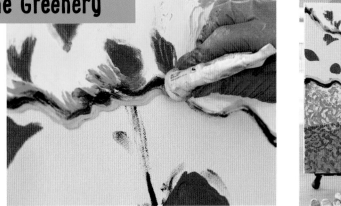

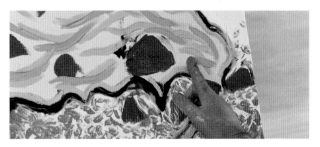

1 Clean your fingers and pick up Yellow Green. We are going to run this color along the inside border of the dark-green outline of the flower space. With your pointer finger and thumb, gently squeeze the tube and apply the paint onto the canvas directly, following the dark-green outline all the way around.

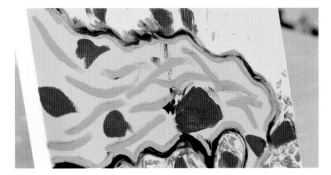

2 We're going to use a lot of Yellow Green now, laying down plenty of color to make 12 snake-like, horizontal lines inside the border of the greenery, avoiding the pink flowers. You want to have a strong touch when laying down these lines; you're trying to achieve ridges on either side of the paint, and when you press firmly that's when you create the ridges on both sides.

3 Clean your fingers and pick up Horizon Blue. Place a chickpea-sized amount on your pointer fingertip and use the same snake-like stroke as in Step 2 to apply the Blue. We're after a partial collision between the Blue and Green. Pretend this section is a river, and follow the flow of the green lines with the blue ones. Overlap with some of the green lines and not others, adding some blue lines in between the green lines. Make a total of 12 blue lines, including some shorter ones around the pink flowers, going right up to the borders.

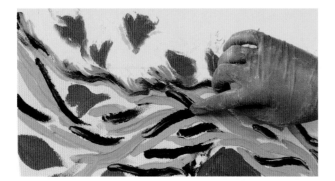

4 Clean your fingers and pick up Phthalo Green. This is a very strong color so make shorter lines next to the green (Yellow Green) and blue lines, following the same flow of the river. The goal is to cover up all of the white canvas with this pattern. Place a hint on your pointer fingertip and apply shorter snake-like lines around the Yellow Green and Blue. Go up to the edge of the flowers, but don't panic about touching the pink—it's going to happen!

5 Clean your fingers and pick up Lemon Yellow. Continue filling in the river with yellow snake-like strokes. The strokes are going to get smaller and smaller as you fill in more color. You're going to start getting all these color collisions, especially with the Yellow touching the dark green—it will create a lovely light-green color. You can overlap the yellow on the dark green and the blue slightly. When you notice a particularly beautiful color collision, try not to cover it up. This is a dance to hide the white canvas, keeping pretty accidents, and breaking up zones of monotony.

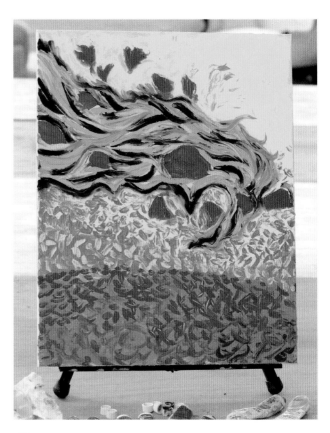

6 Continue to fill in the space with Lemon Yellow. If you notice any large blocks of white canvas or a color-blocked spot—meaning areas of your canvas that are just one color—apply the strokes in a different color to those spots. There should not be too much canvas visible.

7 If you have filled in white spaces with other colors, clean your fingers and pick up Lemon Yellow. Place a chickpea-sized amount on your pointer fingertip and make about 3–4 small wispy tails coming out of the right side of the river of color, flowing into the solid Luminous Lemon background. I consider them Medusa-like strokes that are a beautiful blend of colors. Clean your fingers and reload your finger each time.

8 Here's what your painting should look like at this point. If you're new to finger painting, I would encourage you to continue copying my steps so you build confidence.

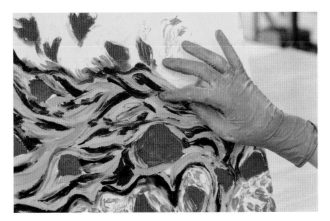

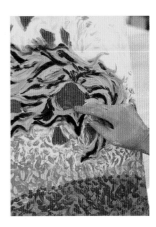

10 Now, right around the first bell we drew in Step 3 (Block Out the Flower Placement, page 106), I want you to imagine the river of color is flowing downward. So dab the purple into strokes downward from the bell.

9 Clean your fingers and pick up Luminous Violet. Place a chickpea-sized amount on your pointer fingertip and dab it into the river pattern wherever you see white canvas. Make small dabs because it's a dark and strong color.

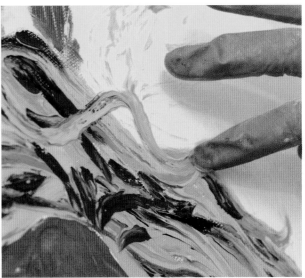

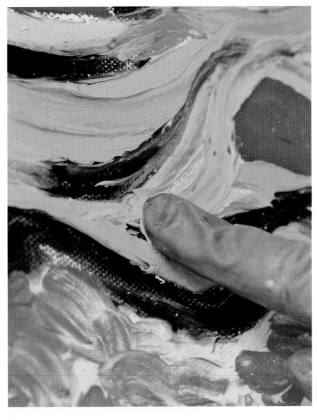

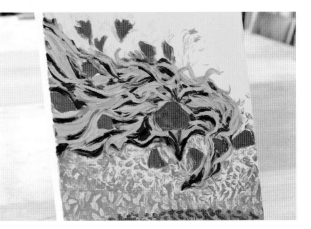

11 Clean your fingers and pick up Ice Green. Place a chickpea-sized amount on your pointer fingertip. Find the dark-green spots in the "river" and push the Ice Green through the dark green in a long snake-like stroke using a light touch. Break up any long strokes with Ice Green to change the pattern up. The colors will swirl beautifully and unpredictably.

12 Make Medusa-like strokes coming from the river out into the solid Luminous Yellow background (as we did in Step 7), making sure you go from the river out into the Yellow and not from the Yellow into the river. Create several strokes along the top, and a few at the bottom, cleaning your fingers and reloading paint as needed.

Continue Painting the Flowers

1 We're going to switch gears now and make the suggestion of flowers in the yellow background with Luminous Orange. I like to jump around my canvas because it keeps my perspective fresh and helps me not to become too fixated and tight. Remember that there is nothing more here than colors, shapes, and strokes on a canvas. There is no vase of flowers—it's just an illusion. We're going to work in the upper-right-hand corner of the canvas near the pink flowers; however, we don't want to cover up the bleed lines of the pink flowers. Pick up Luminous Orange. Dab a chickpea-sized amount on your pointer fingertip and dab feather-like strokes near the pink flowers above the "river," cleaning your fingers and reloading paint as needed.

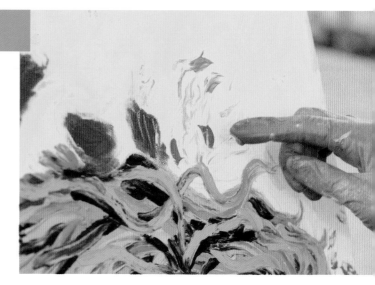

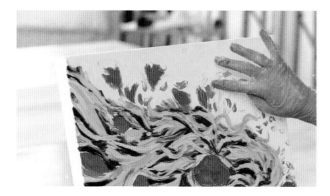

2 You can also feather these orange dabs into the body of the river in any places you see white left. Create a few more orange dabs around the flowers above the river.

3 Clean your fingers and pick up Naphthol Red. Place a chickpea-sized amount on your pointer fingertip and create strokes on the undersides of the pink flowers. Apply to all of the flowers except those above the river (I am only applying this stroke to one flower right above the river); we don't want to apply the paint to the more stroke-like flowers in the distance. Push right into the greenery with this stroke.

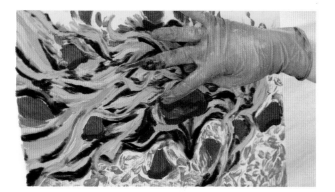

4 In addition to the underside stroke, run a gentle squiggly line on an angle through the center of the first flower we created—this will create the illusion of a fold in the flower.

5 Dab a few specks of Red into the greenery here and there.

6 Clean your fingers and pick up Luminous Orange. Place a chickpea-sized amount on your pointer fingertip and smash it into the top of the first bell shape/flower (above the squiggly line in the center of the flower), leaving some pink visible. This is going to be the highlight line. Add a bit of Orange to the upper-right edge of the flower as well.

7 Clean your fingers and reload paint as needed. Repeat on all the other flowers that have the red understrokes, applying just a small messy stroke in the center and along the edge of each flower.

Finish the Table

1 Let's switch gears again and move to the orange table on the lower half of the canvas. Clean your fingers and pick up Luminous Opera. Place a pea-sized amount on your pointer, middle, and ring fingertips and dot into the Orange—it's kind of like sponge painting with your fingertips. When the paint starts to become faint, it's time to reload your fingers (and clean them). Create a light layer across most of the orange section.

2 Clean your fingers and pick up Lavender. Repeat the same dotting pattern as in Step 1, moving all over the table. The table is a reflective surface for me, picking up all the colors in the room. I'm not necessarily covering the whole space with this pattern with any color. The strokes can get a little larger toward the bottom of the canvas because they are closer to us. Make your dots, but don't be too pattern-y. Avoid a polka-dot dress look.

3 Clean your fingers and pick up Yellow Green. Repeat the same dotting pattern. You're really just highlighting here, not covering the whole table.

4 Clean your fingers, pick up Horizon Blue, and repeat the same dotting pattern, but with just your pointer and middle fingertips. If you see a blob of Red, it's a good area to cover with this color. I get good coverage with the Blue, across most of the table, making larger strokes at the bottom of the painting. Look at that beautiful collection of colors!

Paint the Vase

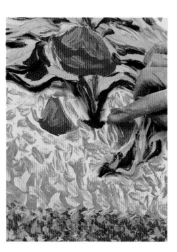

1 Clean your fingers and pick up Luminous Opera. Below the first bell shape created in Step 1 (Block Out the Flower Placement, page 106), underneath the point of the river, paint a line that looks like a smile. This will be the top of the vase.

2 Clean your fingers and reload Luminous Opera. About an inch (2.5 cm) below that, create another smile shape with a very light touch. It should trail off on the right side.

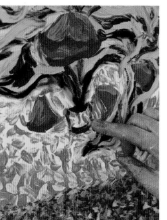

3 Connect these two lines with a very faint purple, vertical line on each side. Let the yellow on the canvas naturally peek through your purple swipes.

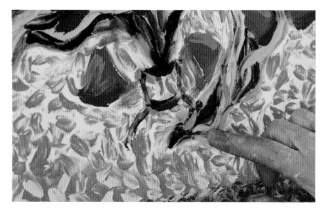

4 Extend the lines outward with an arched line on either side of the bottom smile line. They should look like the shoulders on a bottle.

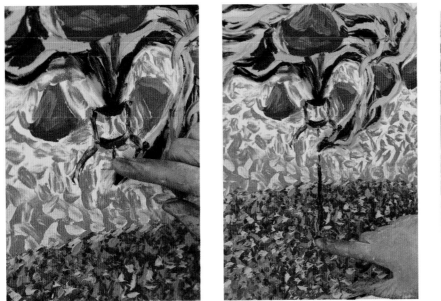

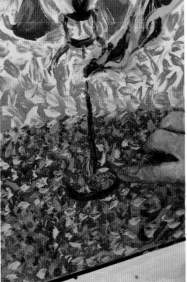

5 Clean your fingers and reload Luminous Opera. From the bottom smile line, draw a light line down the center of the vase, extending down to about 3 inches (7.5 cm) from the bottom of the painting.

6 At the bottom of the middle line, draw a smile shape to create the rounded bottom of the vase.

7 Connect the ends of the canoe-shaped base up to the shoulders created in Step 4 at the top of the vase.

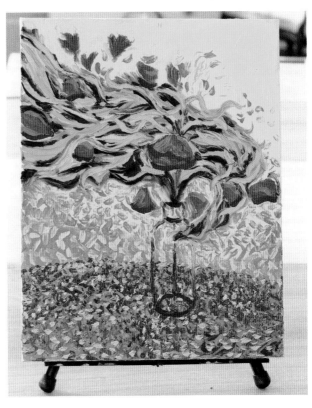

8 Create a frown on top of the smile to form the inside of the bottom of the vase.

9 Here's what your painting should look like at this point.

10 Clean your fingers and pick up the Phthalo Green. Keep in mind that this vase is thick glass so the stems of the flowers are not going to extend to the bottom of the vase, nor will they touch the inside edges too tightly. Beginning at the top of the vase, make one pass to create each stem. Some should go almost to the bottom, others should be angled to the left and right, and a few should remain right at the bottleneck. Create a few and then we'll come back to this. Clean your fingers and reload paint as needed.

Create the Swirl Effect

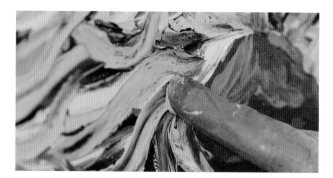

1 Clean your fingers well and pick up Naples Yellow. We're going to use this to tone down some of the colors in the foliage/river. It looks great on top of the brighter colors. Place a chickpea-sized amount on your pointer fingertip and, with a light touch, paint into the dark green of the river in a wavy pattern around and on top of the Green. Bring the wavy lines with this color toward the center of the bottle. Repeat on any spots that are too color-blocked or that need lightening up.

2 A gorgeous color combination happens when the Green and Naples Yellow wrap around each other, which you can achieve by creating a stroke and then coming back over the exact stroke you made, then going back over the stroke again. Don't forget to clean those fingertips!

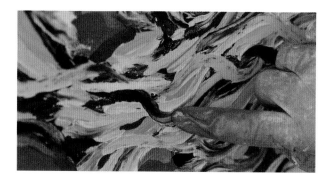

4 Here's a shot of what your painting should look like at this point. If you are still too color-blocked, break it up with a contrasting color addition.

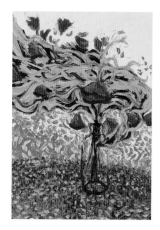

3 Now we can start grabbing already-painted colors and pulling them back through each other. This will create a cool helix-style wrapping effect. In places where there is too much concentration of one color, pull another color over it. You can just push and pull what's already on the canvas, without needing to squeeze more paint from the various tubes. You can do this in either direction—it will create a woven effect. Clean your hands each time, and be sure to follow the flow of the river, with some strokes turning downward into the bottle.

Continue Painting the Vase

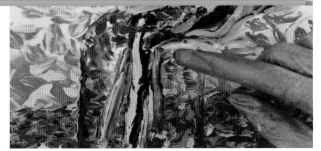

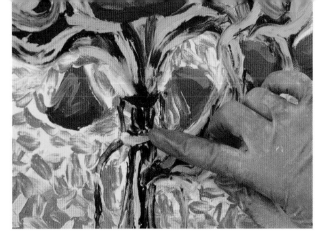

1 Clean your fingers and pick up Lemon Yellow. Place a chickpea-sized amount on your pointer fingertip and run it along the green stems in the vase with a very light touch.

2 Clean your fingers and create a highlight across the neck of the vase with Lemon Yellow.

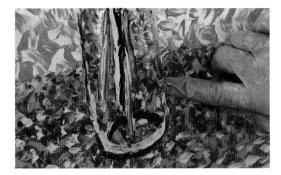

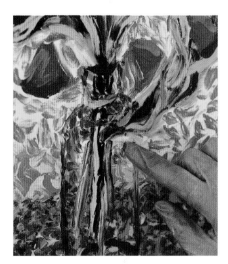

3 Clean your fingers and pick up Naples Yellow. Trace the inside of the smile shape at the bottom of the vase with the Yellow, slightly coming up on the sides of the vase.

4 Clean your fingers and pick up Luminous Opera. Place a chickpea-sized amount on your pointer fingertip and create small, clustered dabs at the top of the vase in the left-hand corner, flowing over to the center. Continue down the left side of the vase, cleaning your fingers and reloading paint as needed.

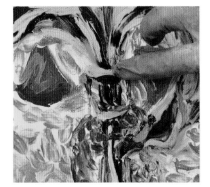

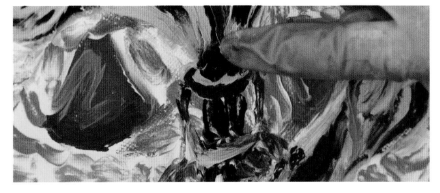

5 Clean your fingers and pick up Ice Green. Place a pea-sized amount on your pointer fingertip and trace on top of the purple smile-shaped line at the bottleneck of the vase.

6 If the stems get lost, take the Phthalo Green and dab a little at the top of the vase. Tip: Take pictures of your painting every fifteen minutes with your phone, and then review your work. You'll maybe notice that you have a tendency to over-touch areas of the painting that were previously bright. Remember this classic obstacle as you continue with your painting. Less can be more sometimes!

7 Clean your fingers and pick up Cobalt Blue Hue. Place a chickpea-sized amount on your pointer fingertip and make small dabs underneath the vase to create a shadow. Dot the Blue in an elongated V shape to the left and below the vase. Don't obliterate the Orange, though, with too much Blue. Let the Blue trail off toward the bottom of the shadow.

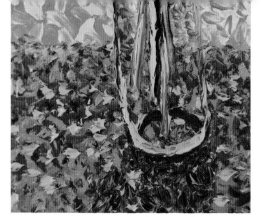

Add Details to the Greenery

1 Let's go back to the flowers and pull some leaves in front of the vase. Clean your fingers and pick up Lemon Yellow. Place a chickpea-sized amount on your pointer fingertip and, on the bottom of the river, create a squiggly line coming into the yellow background and orange space below it. If your stroke is too one-color, grab paint from a surrounding area and bring it into the Lemon Yellow. Don't copy the exact pattern with each stroke—you want to create similar overlapping patterns, coming into and out of each other. The patterns should be completely random.

2 Repeat in a few areas along the bottom of the river. This is the point of the painting where you can mine from existing paint in the foliage; you may not even need the Lemon Yellow. Create Medusa-like strokes with various colors.

3 Move to other areas of the river and repeat. You can pull some areas directly off the right side of the painting. In areas where one color is too concentrated, pull other colors through it. I'm pulling purple through this area, which is too blue and pronounced around my flowers. This technique is much like braiding hair; a light touch allows you to pull paint that's already on the canvas through the surrounding colors. How cool!

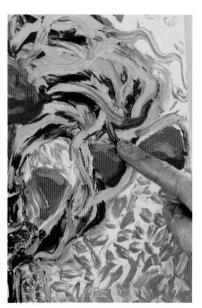

4 I'm also adding a green stem coming out from the top of my river because I think this area is a little bare.

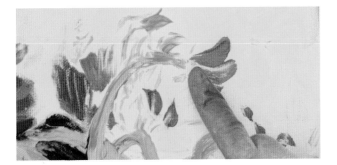

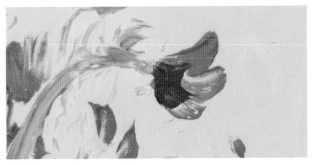

5 Clean your fingers. Now we're going to add a flower to the stem we created in the previous step. Pick up Luminous Orange and place a chickpea-sized amount on your pointer fingertip. Make three or four horizontal strokes, left to right, coming off the edge of the stem.

6 Clean your fingers and pick up Luminous Opera. Place a chickpea-sized amount on your pointer fingertip and dab the center of the flower (at the meeting point of the 3–4 orange strokes).

7 Now let's work on creating more depth and dimension in areas that look flat, purging certain sections and adding to others by pushing colors. To lighten darker areas, use Naples Yellow to push through the dark colors, since it's a contrasting color. Naples Yellow works particularly well as a contrast for dark green (Phthalo Green).

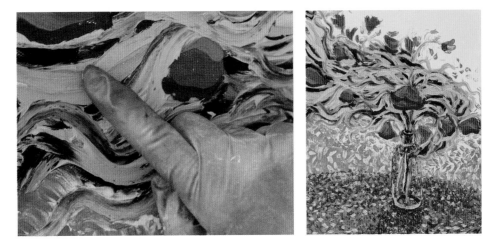

Make the Finishing Touches

1 Clean your fingers and pick up Naphthol Red. Place a pea-sized amount on your pointer fingertip and add to the right side of the vase to create more of a presence. Also add a few dabs in the upper-right corner of your painting.

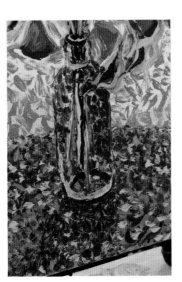

2 Clean your fingers and pick up Luminous Opera. We're going to apply short strokes into the river in places that are too green, and to any place that doesn't have a contrasting color. This is going to create the illusion of flowers underneath the stems.

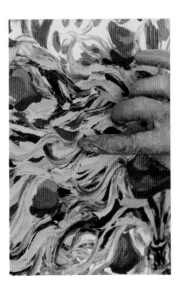

3 Clean your fingers and pick up Yellow Green. We're going to use this to create stems and connect the flowers above the river. Place a pea-sized amount on your pointer fingertip and make an arched line from the center of the flower into the river.

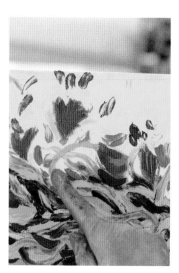

4 For the smaller flowers at the very top, make a faint, dotted, and arched line connecting them into the river.

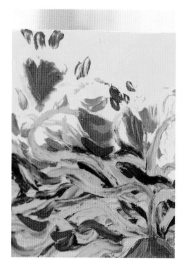

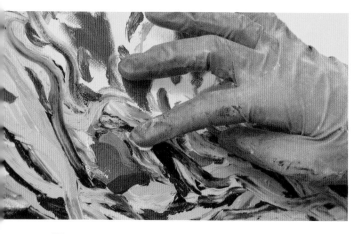

5 It looks like some areas of my river are still a bit too dark, so I'm picking up Lemon Yellow and adding it to areas that are too green. I'm also using it to create more wispy pieces of foliage coming out of the river into the Yellow.

6 Clean your hands and pick up Luminous Orange. We are going to give depth to the flowers by adding highlight points with short strokes at the top and sides of each one.

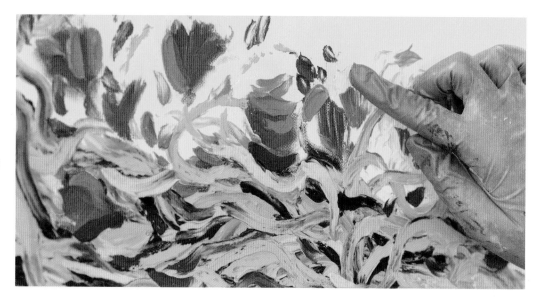

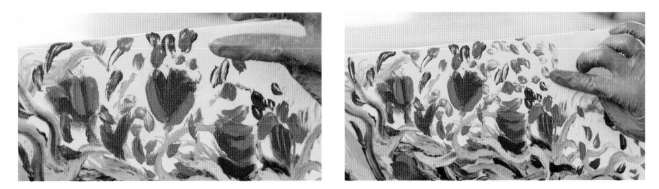

7 Now make short punchy dabs, all different sizes and directions, clustered in the top-left part of the canvas around the top flowers. As you move toward the center and to the right of the canvas, let the dabs trail off and become fainter and smaller.

8 Continue dabbing on the right side of the canvas, with the dabs becoming larger close to the green river and getting fainter at the edges and the top. Place some dabs in different directions right across the stems.

9 Clean your fingers and pick up Ice Green. Place a chickpea-sized amount on your pointer fingertip and make snake-like squiggles moving left to right on an upward angle in the top-left part of the river. Continue down the left/center of the river with these strokes.

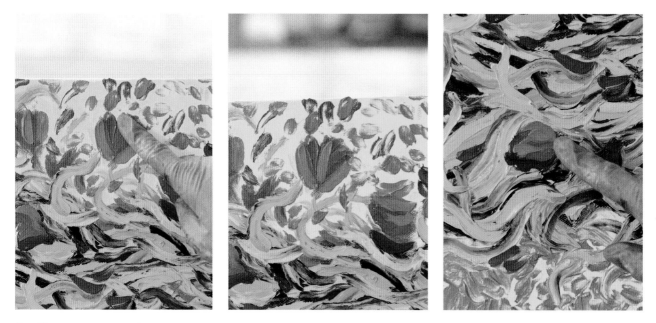

10 We're almost there! Step back and take a look at your painting from afar. Text a picture to a friend and ask for feedback. Stepping back here, I can't help noticing that some of the flowers look flat or seem to be lacking depth so I'm swiping another orange stroke through a few of them to add more depth and highlight. I'm also pushing the highlights (like the Yellow) into the pink so they're not as obvious.

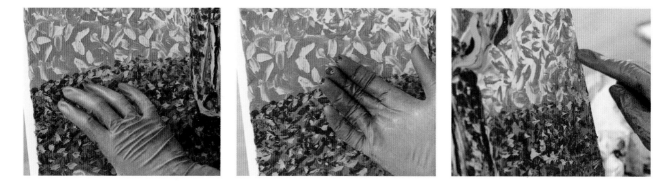

11 The final step is contaminating your pointer, middle, and ring fingers with the multicolored paint from the table and making very light dots in clusters above the table line, into the Orange. Don't dot the entire space or go too close to the center; stick to creating a shadow up the left and right sides of the canvas that trails off naturally.

12 If you are going to frame your painting, you don't need to paint the edges. If you're not going to frame it, wrap the image around the sides of the canvas. Let your painting dry for 3–4 weeks.

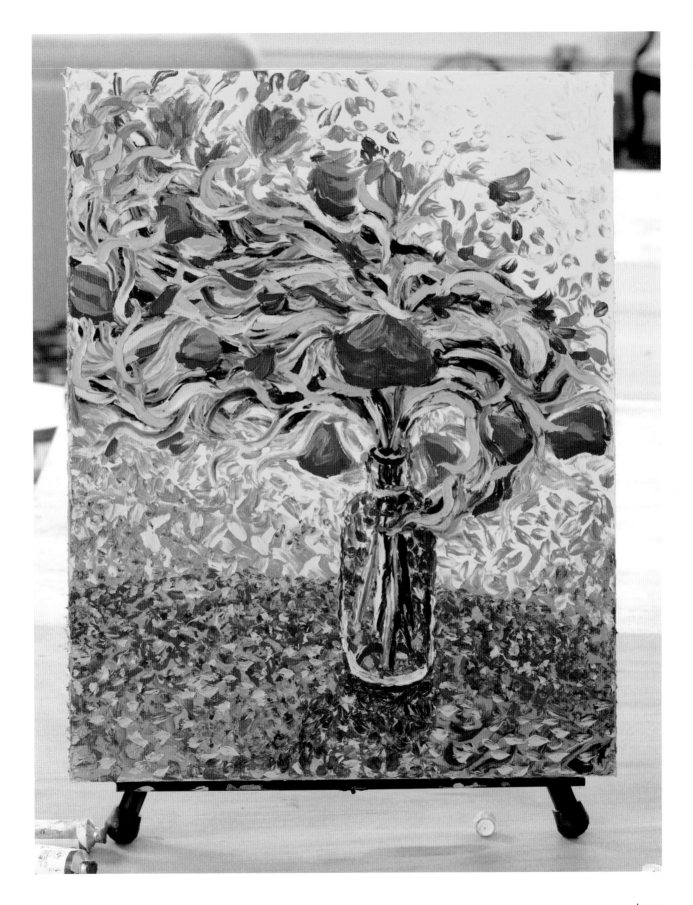

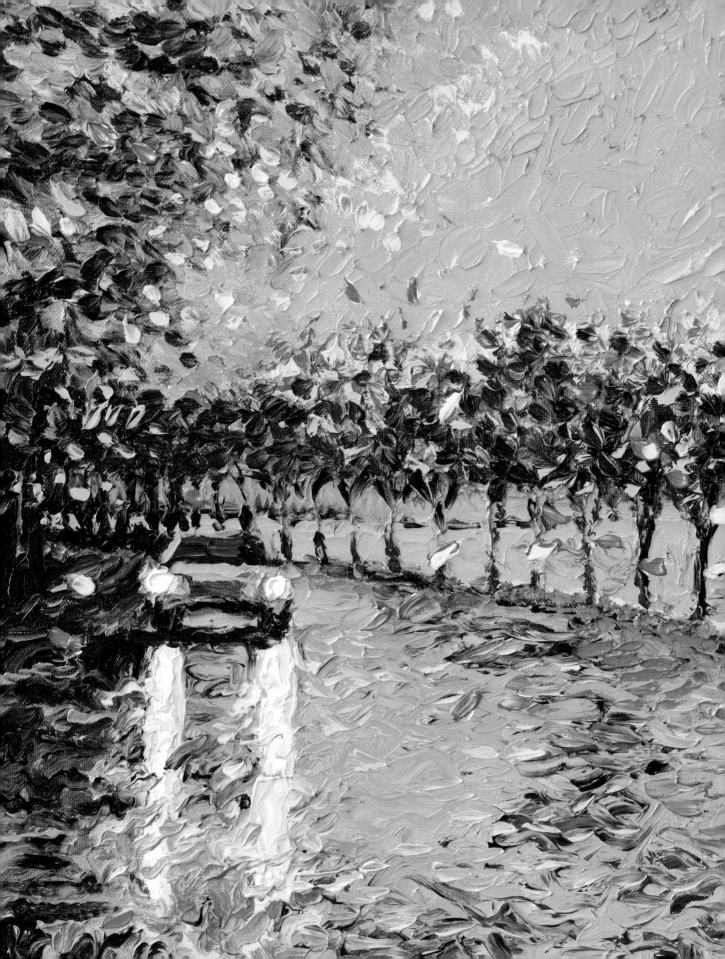

WET ROAD

I was born and raised in the Seattle, Washington, area—the land of gray skies and wet windshields—so rain-drenched streets are a scene all too familiar for me. But forget the idea that rainy weather means dreary colors! A wet road can be so saturated with color that it's mind-boggling. This is especially true in the autumn, when leaves fall into street puddles that reflect neon lights and oncoming headlights.

A wet windshield distorts reality in subtle, impressionistic ways. Similar to looking at koi fish through inches of water, a windshield can blur our view and help us beautifully imitate the works of the masters. Use the blurriness of this image as an excuse to get rid of your ideas of perfection! This image isn't perfectly sharp, none of the lines are perfectly straight, none of the leaves are fully formed. But the idea of the wet road is unmistakable. Set up your canvas, put on your gloves, and pop the caps off of your paint tubes. Let's get started!

MATERIALS

TOTAL PAINT
AND PREP
TIME:
4–6 HOURS
(TO BE DONE IN
ONE SITTING)

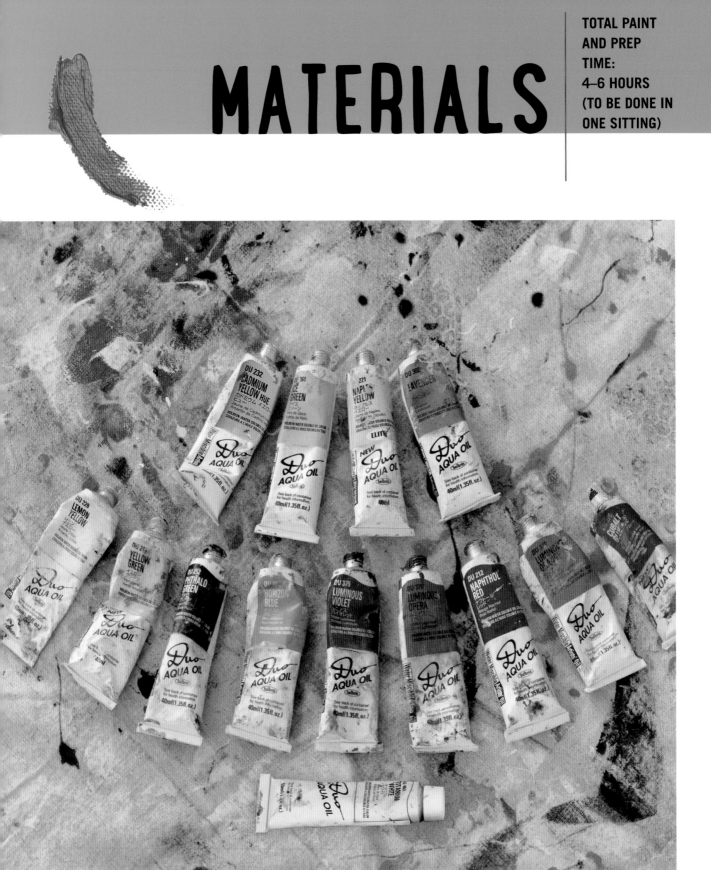

What You'll Need: latex gloves; 16 x 20-inch (41 x 51 cm) canvas; easel; roll of paper towels

14 oil colors: Phthalo Green, Cadmium Yellow Hue, Lemon Yellow, Cobalt Blue Hue, Naples Yellow, Yellow Green, Ice Green, Horizon Blue, Luminous Violet, Luminous Opera, Luminous Orange, Naphthol Red, Lavender, Titanium White

▲ Set up your canvas horizontally on your easel and place your roll of paper towels close by. Put on your gloves and remove all the paint caps.

Outline the Trees

1 Place a chickpea-sized amount of Phthalo Green on your pointer fingertip. About an inch (2.5 cm) to the right of the middle of the canvas at the top, create a rabbit-foot pattern down the canvas and angled to the left, ending around the middle of the left side of the canvas. This is the green tree line. Reload paint as needed.

2 Clean your fingers and pick up Cadmium Yellow Hue. Place a chickpea-sized amount on your pointer fingertip and head to the top-right corner of the canvas. Make the same rabbit footprints swooping down and plateauing about one-third of the way down the canvas. Continue the pattern to the left until you hit the green tree line you made in Step 1. This is going to be the tree line on the opposite side of the street. Reload paint as needed.

3 Clean your fingers and find the middle of the canvas on the right side. Starting just below that halfway point, with the Cadmium Yellow Hue, create a gently sloping dotted line with an upward trajectory to the green tree line. Reload paint as needed.

4 Clean your fingers and pick up Lemon Yellow. One-quarter of the way up from the bottom right of the canvas, draw an upward sloping line ending about an inch (2.5 cm) below the green tree line on the left side of the canvas.

Outline the Car

1 Clean your fingers and pick up Cobalt Blue Hue. We're going to vertically divide the canvas on the left side into thirds by dotting it with the Blue to create markers. Place a chickpea-sized amount on your pointer fingertip and mark the canvas into thirds, making 4 dots—one at the top-left corner, one at the bottom-left corner, and 2 in the middle. Drag the paint across the canvas from the third dot from the top to make a faint line.

2 Repeat on the bottom of the canvas, making 3 additional dots to the existing bottom-left corner dot, to divide it into thirds horizontally.

3 Draw a vertical line upward from the dot second to the left at the bottom of the canvas that runs past the faint blue horizontal line and meets the yellow line.

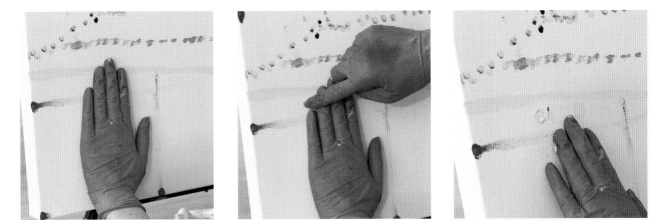

4 Tuck your thumb into your hand and, using your four fingers, place your hand in the middle of the box. This will be about the width of your car. Place a dot of Lemon Yellow in the place of your pinky and your pointer fingers (this will depend on the size of your fingers).

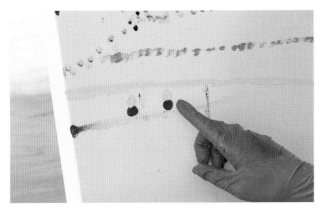

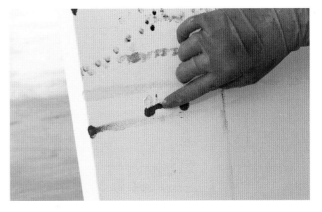

5 Clean your fingers and pick up Cobalt Blue Hue. Place a small dot directly underneath and touching each yellow dot.

6 With a light touch, draw a dotted thin Blue line to connect the 2 blue dots along the top edge of the dots.

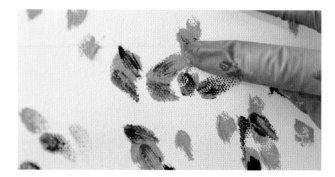

1 Clean your fingers and pick up Cadmium Yellow Hue. Place a chickpea-sized amount on your pointer fingertip and dab at the top-left corner of your canvas inside the green tree line. Dab in a loose, wavy pattern, filling in and staying within that tree line.

2 Clean your fingers and pick up the Phthalo Green. Repeat the same pattern. Collide some of the Green with the Cadmium Yellow—you'll see something beautiful happen! Don't go overboard with the Green; you want a couple of dozen green dabs. Clean your fingers and reload paint as needed.

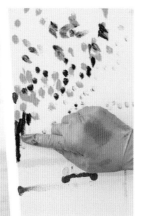

3 On the left side of the canvas just above the yellow line, with the Phthalo Green, draw 3 longer, thick lines coming from the Cadmium Yellow dots and stopping at the yellow line. Alter the length of the lines slightly at the top (in the Yellow dots).

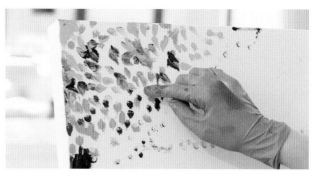

4 Clean your fingers and pick up Yellow Green. Keep your paper towel in your left hand. Place a chickpea-sized amount on your pointer fingertip and continue with the dotting pattern in the top-left corner, letting it collide occasionally with the Phthalo Green. Pay attention to how you get beautiful leaves and leaf structures through these collisions. Continue dabbing and reloading. You should get about five dabs from each paint amount.

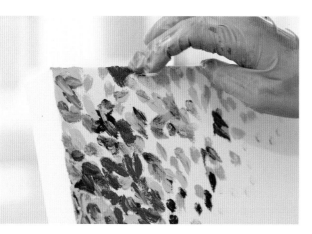

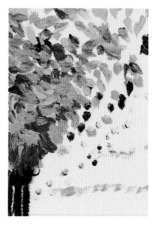

6 Clean your fingers and pick up Cadmium Yellow Hue. Place a chickpea-sized amount on your pointer fingertip and repeat the dabbing pattern in the top-left corner, wiping your fingers and reloading paint every 5–6 dabs. The pattern will start to look like trees once you begin to eliminate the white canvas.

5 Clean your fingers and pick up Cobalt Blue Hue. Place a chickpea-sized amount on your pointer fingertip and repeat the same pattern in the top-left corner, cleaning your fingers and reloading paint as needed.

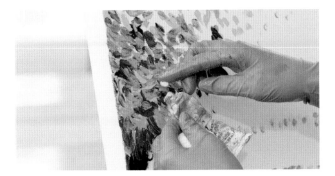

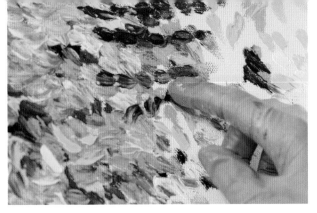

7 Clean your fingers and pick up Lemon Yellow. Place a chickpea-sized amount on your pointer fingertip and repeat the dabbing pattern in the top-left corner, wiping your fingers and reloading paint every 5–6 dabs.

8 Continue with the dabbing pattern with Cobalt Blue, Cadmium Yellow Hue, Yellow Green, Phthalo Green, and Lemon Yellow until you fill the space. I've noticed that, when it comes to trees, making abstract Z patterns will give the illusion of branches, so I'm creating this pattern with Phthalo Green.

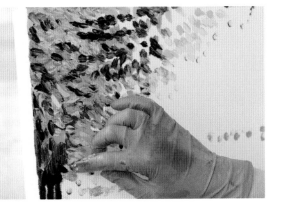

9 Clean your fingers. Toward the edge of the canvas, dab Yellow Green and Lemon Yellow closer to the original tree line drawn in Step 1 (Outline the Trees, page 132). Don't go all the way to the tree line (you want it to sort of trail off), and be mindful not to touch the tree line with these colors. If you do touch the tree line, clean your fingers and move on. We can fix it later.

Paint the Sky

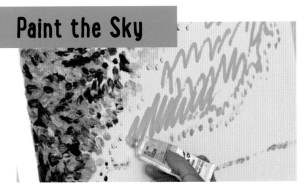

1 Clean your fingers and pick up the Ice Green tube. With your thumb and pointer finger, apply it in squiggly lines between the green tree line and the yellow tree line, in the upper-right half of the canvas.

2 Clean your fingers and pick up Horizon Blue. Place a chickpea-sized amount on your pointer fingertip and dot it in between the Ice Green squiggly lines.

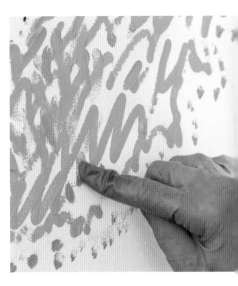

3 With your pointer finger, blend with dabs into the Ice Green. Use a dabbing crisscross motion going in several different directions but not up and down. If you feel a scratchy feeling on the canvas, you'll know you need to add more paint. If so, grab it. Don't go quite to the yellow tree line with the paint, but get pretty close. Create subtle Z patterns to create a more organic feel

4 Clean your fingers and pick up Lavender. Place a chickpea-sized amount on your pointer fingertip and randomly dab this into the Ice Green and Horizon Blue in different directions, starting on the top edge and working down. Mix the colors together—you want to give the illusion of a cloudy day. Add in some more Horizon Blue if it's too green. Clean your fingers after a couple of dabs and reload paint as needed.

5 Clean your fingers and pick up Ice Green. Place a chickpea-sized amount on your pointer fingertip and start moving into the trees with it. Dot in a step pattern into the trees, moving from the sky into the trees, not from the trees into the sky—like the paint is walking into the trees. Try just filling in around the leaves and not going directly over them, though you will have some overlap.

6 Clean your fingers and pick up Yellow Green. Place a chickpea-sized amount on your pointer fingertip and fill in the remaining white canvas on the trees. Use small, uniform dabs, going in slightly different directions with each stroke. At the bottom, the leaves should jut out a bit more and come underneath the blue sky. Clean your fingers and reload paint after 5–6 dabs.

7 Clean your fingers and pick up Horizon Blue. Place a chickpea-sized amount on your pointer fingertip and continue the dabbing pattern. The more we touch this and step the Horizon Blue into the green trees the more fabulous it's going to look. But we don't want to go over the same places over and over again. Try to address concentrated areas of a lot of Green by walking the Blue into the Green. Once you've covered up the white of the trees and the sky, walk away!

Paint the Sky Below the Trees

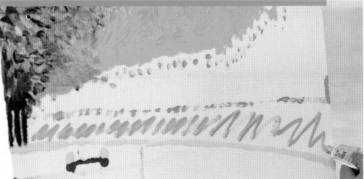

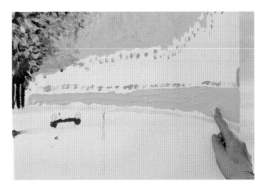

1 Clean your fingers and pick up Ice Green. Apply the tube directly to the canvas to fill in the space between the yellow street line and the bottom of the orange tree line.

2 With very clean fingers, fill in the space with left-to-right strokes. Go right up to the yellow line but be mindful of the orange line. If you have extra paint, use it to create more texture in your sky.

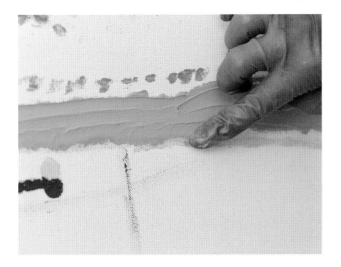

3 Clean your hands and push the Ice Green down into the yellow line, just barely filling the gap between the Blue and the Yellow. This movement will create a green color, and when it gets too green, clean your fingers. The paint is allowing us to create an atmospheric sense of a foggy grass line.

4 Clean your fingers and pick up Horizon Blue. With your pointer finger, place a small amount between the dark green (Phthalo Green) tree trunks on the left side of the canvas from Step 3 (Create the Leaves, page 134). Your hands will be larger than the space in between the trees, but, with clean hands, drag the Green from the top of the trunks to the bottom. Now the trees are in the foreground again and you'll get combined edges. Cool!

5 Now we're going to fill in the gap between the Ice Green and the Cadmium Yellow Hue. This is going to be the underbelly of the trees on the opposite side of the street. Clean your fingers and pick up Horizon Blue. Place a chickpea-sized amount on your pointer fingertip and draw a thick horizontal line below the Cadmium Yellow line.

Start the Road

1 Clean your fingers. Find the third blue mark from the left at the bottom of the canvas and draw a faint vertical sketch-line up to the Lemon Yellow line.

2 Clean your fingers and pick up Cobalt Blue Hue. Beginning at the mark at the bottom-right corner of the canvas, draw a sloping line upward that meets the Lemon Yellow line and trails off, ending at the right headlight of the car.

3 Clean your fingers and pick up Lemon Yellow. Place a chickpea-sized amount on your pointer fingertip and fill in the gap in the upper-right space you just created. Use horizontal strokes—you'll pick up a little Cobalt Blue, which is okay.

4 Clean your fingers and pick up Cobalt Blue Hue. Place a chickpea-sized amount on your pointer fingertip and color in the left side of the car inside the sketch-line, going up to the left headlight but not touching it.

5 Clean your fingers and pick up Luminous Violet. Place a chickpea-sized amount on your pointer fingertip and create a section of vertical strokes below the Cobalt Blue, each stroke trailing off at the bottom, but colliding messily with the Blue above.

6 Clean your fingers and pick up Cadmium Yellow Hue. Place a chickpea-sized amount on your pointer fingertip and repeat below the Luminous Violet from Step 5.

7 Clean your fingers and pick up Lemon Yellow. Blend into the Cadmium Yellow Hue from Step 6, going to the bottom of the canvas.

8 With Lemon Yellow, make a thick vertical line starting directly underneath the left headlight and moving straight down to the bottom of the canvas (these are going to be the headlight reflections). Stop about 2 inches (5 cm) from the bottom and then repeat on the other headlight. Move some of the Cadmium Yellow Hue into the headlight by blending it lightly with Lemon Yellow on the left headlight shadow. Be very generous with the paint here.

9 Clean your fingers and pick up Horizon Blue. Make a similar thick vertical line to the left of the left headlight, going right into the colors from Steps 5, 6, and 7.

10 Create 3 thick vertical lines with Horizon Blue in between the headlight shadows, ending halfway down.

11 Clean your fingers and pick up Ice Green. Fill in the rest of the space with Ice Green vertical lines all the way to the bottom of the canvas.

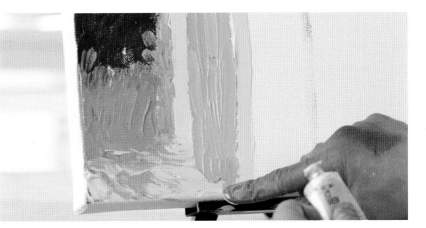

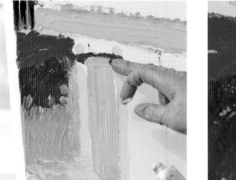

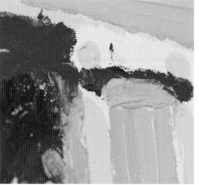

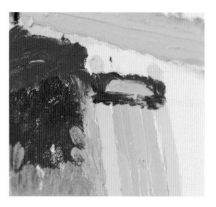

12 Move to the top and draw a horizontal line beneath the Cobalt Blue horizontal line from Step 6 (Outline the Car, page 133) connecting the two headlights, letting the paints blend. And when I say "blend," I'm saying let the colors kind of grab each other, allowing some swirly mixing action along their edges. You cannot plan this, but you need to let interesting "accidents" remain. Let those microscopics live—don't kill them by covering them up!

13 Clean your fingers and pick up Luminous Violet. Make a longer horizontal line that connects from the purple on the left of the canvas over the Horizon Blue line to the right headlight.

Fill in the Car and Road

1 Clean your fingers and pick up Ice Green. Apply the tube directly to the canvas using a horizontal zigzag pattern (with a few vertical strokes like I've done to fill in most of the remaining white space in the lower-right corner of the canvas. We're going to leave a path of white canvas following the slope downward. Cover up those blue sketch-lines; there's no need for them anymore. Go right up to the yellow headlight shadow line.

2 Use your pointer, middle, and ring fingers to blend the paint into the canvas, adding more paint if needed. Fill in the entire white space up to the headlight but leave a small band of white at the top—we're going to fill this in with Lavender.

3 Clean your fingers and pick up the Lavender. Fill in the top white band with Lavender, blending into the Ice Green.

4 Clean your fingers and pick up Ice Green. Draw a horizontal line between the 2 yellow headlights.

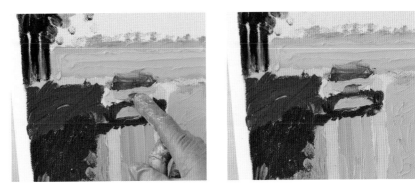

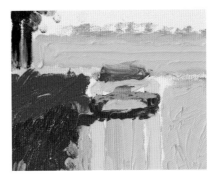

5 Clean your fingers and pick up Cobalt Blue Hue. Place a pea-sized amount on your pointer fingertip and make small dots above the yellow headlights toward the inside edge of each one. Pull your finger back and forth between the dots to create a swirly, trapezoid shape.

7 Add a license plate at the bottom of the space in between the headlights by painting a short horizontal stroke of Cobalt Blue Hue in the lower center of the Ice Green. Go back over the stroke a few times to blend the paint slightly. Whenever you attempt to paint a certain stroke and it turns out not to be what you expected, first pause and ask yourself with squinty eyes, "Hey, does it work after all?" And if the answer is still "no" then wipe your fingers off—that usually solves the unpredictability of stroke work. Also, a light touch invariably offers more control. Pressing too hard can push you through layers and begin activating colors you didn't realize were even on the canvas!

6 To create the windshield, paint a small horizontal swipe between the Cobalt Blue shapes from Step 6 (Outline the Car, page 133). The lines should be imperfect—we want this to look blurry and abstract.

8 Clean your fingers and pick up Cadmium Yellow Hue. Paint a horizontal line underneath the yellow headlights, a little over the Cobalt Blue horizontal line, right underneath the license plate.

9 If you see any remaining white canvas, fill it in with the appropriate color. I see white in my Ice Green areas so I'm using Ice Green to get rid of it in between my headlights.

10 Here's a shot of what your painting should look like at this point, with a close-up to show how rich and lush it looks!

Add Leaves and Flowers

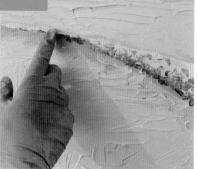

1 Clean your fingers and pick up Phthalo Green. Place a tint on your pointer fingertip (this green is very strong and goes a long way) and create a small dotted-line pattern along the bottom of the yellow band in a left-to-right pattern. As you get closer to the car, trail off the pattern and create more of a steady line. Go right up to the headlights of the car. Green is super staining, so unless it all but disappears, there's no need for a lot of it.

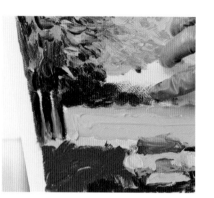

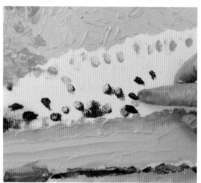

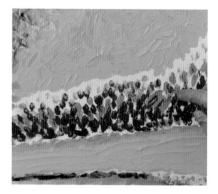

2 Clean your fingers and pick up Luminous Violet. Place a pea-sized amount on your pointer fingertip and dab underneath the tree line on the left side of the canvas, hugging the orange line. You don't need a lot of paint—you want a light touch of dots. Create a more concentrated area of purple toward the bottom of the trees and get thinner as you move away from the tree line, creating a random dot pattern. For the next 5 steps, clean and reload your finger with paint as needed. You should be able to get 4–6 dabs out of each paint amount.

3 We're going to leave a small band of white at the top; we don't want the darker colors up there. We're going to fill this in a few steps later with lighter colors.

4 Clean your fingers and pick up Luminous Orange. Place a big dab on your pointer fingertip and dab above the purple dots, going right into the purple cluster on the left side of the canvas. Swoop up on the right side, trying to move in between the purple. Use large strokes on an angle, going in several different directions. As the Orange collides with the purple, it will really fade out, which is what we're going for. Clean your fingers and reload paint as needed.

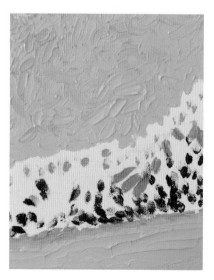

5 Clean your fingers and pick up Naphthol Red. Place a big dab on your pointer fingertip and dab right into the purple dots and in between the Orange and the purple. Don't just cover up the purple—fill in the other areas and cover up the edges of the trees, too.

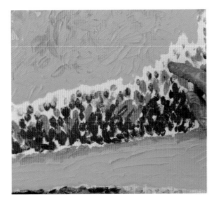

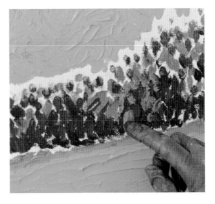

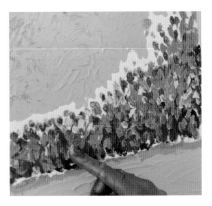

6 Clean your fingers and pick up Luminous Opera. Place a big dab on your pointer fingertip and create the same dotting pattern, covering up the white space.

7 Clean your fingers and pick up Cadmium Yellow Hue. Place a big dab on your pointer fingertip and continue to cover up the white space. Move in a left-to-right and up-to-down pattern.

8 Clean your fingers and pick up Lemon Yellow. Continue with the same pattern, covering up the white canvas and moving over the existing colors.

9 Now's a good time to take a break. Put down the paint, take off your gloves, and have some lunch.

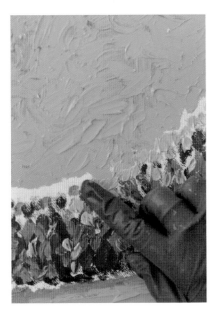

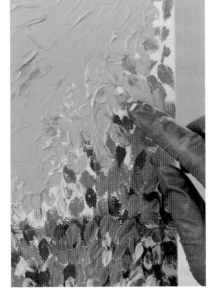

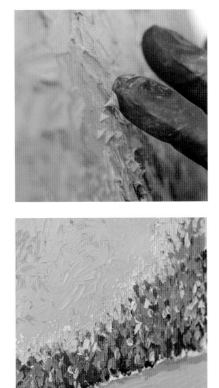

10 Once you've returned, put your gloves back on and pick up Naples Yellow. Place a chickpea-sized amount on your pointer fingertip and begin to fill in the white gap between the blue sky and the top of the tree line. Clean your hands every time. I'm barely going into the Blue, and I'm pushing upward into the Blue with each dab. I'm using Naples Yellow as the first layer of trees because it doesn't really turn to green when it hits the Ice Green, like other yellows—it holds the color very well. The goal is to eliminate all of the last bits of canvas, so go all the way up the right side of the canvas with the dabbing pattern.

11 Using Naples Yellow, make very small dots at the top of the tree line into the blue sky in a few areas. You want to almost make little teepees. Clean your fingers and reload paint as needed.

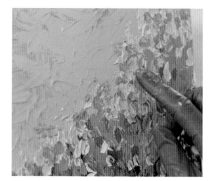

12 Pick up Cadmium Yellow Hue and give a few swipes over any last bits of white. This color looks great when you blast it into the Naples Yellow. Add a few small dots at the top of the tree line as you did in the previous step.

13 Clean your fingers and pick up Luminous Orange. Dot along the bottom edge of the tree line, cleaning your fingers each time. It should be a mild line, not too obvious.

14 With the Luminous Orange, dab on top of the Naples Yellow that you placed in Step 10. You're going to need to clean your fingers a lot—I only manage about 3 dabs before I need to clean my fingers

15 Clean your fingers and pick up Cadmium Yellow Hue. Place a chickpea-sized amount on your pointer fingertip and dab a spaced-out dotted line along the top edge of the yellow path, all the way up to the car. Go around the car and dab on the left side on top of the Cobalt Blue Hue. Be sure not to use too much of the paint, and to space out the dots.

Make the Road Wet

1 Clean your fingers and pick up Lavender. Place a chickpea-sized amount on your pointer fingertip and use a dragging snake-like motion to swirl the Lavender into the Ice Green between the headlights of the car about three-quarters of the way down. This will create the illusion of a wet road—hence the name of the painting! We're going to work on doing this for the next several steps, blending the colors around the car into each other.

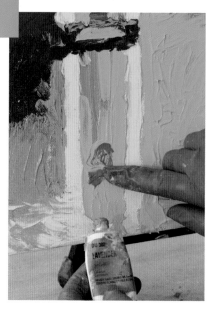

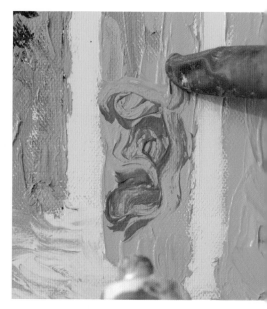

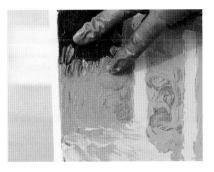

2 Clean your fingers and repeat the same pattern with Lavender on the left side of the left headlight, moving into the Orange and picking up the Orange as you move in and out of the paint. It's one slow pass.

3 Clean your fingers and pick up Luminous Opera. We are going to continue to work into the existing colors around the car to blend colors into each other using a snake-like squiggly pattern. Place a chickpea-sized amount of Luminous Opera on your pointer fingertip and, with a feather-like touch, push into the Cadmium Yellow Hue to the left of the left headlight in a squiggly pattern. Do not pick your finger up; it's almost as if you're writing in cursive without taking your finger off of the canvas.

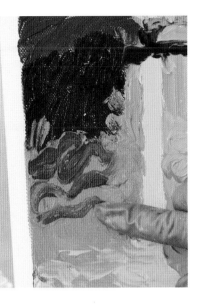

4 Once your finger gets contaminated with Cadmium Yellow Hue, move it down to the Luminous Violet (dark purple) to the bottom left of the left headlight and create the same pattern without picking up your finger.

5 Once your finger gets contaminated with Luminous Violet, move it back down to the Luminous Opera (pink) on top of the Cadmium Yellow Hue and repeat the same pattern.

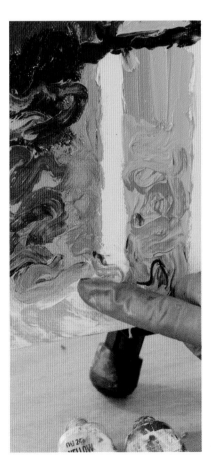

6 Now, Cadmium Yellow Hue to Lemon Yellow is not a strong contrast. So I'm going to move the Yellow into the blue area to the right of the right headlight, deposit it, and then pick up Blue and move it back to the Yellow.

7 Now I'm going to move the Orange back into the Blue between the headlights. Move back and forth over the yellow headlight shadow.

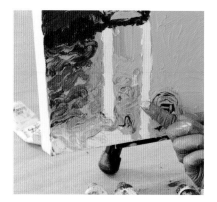

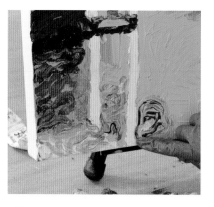

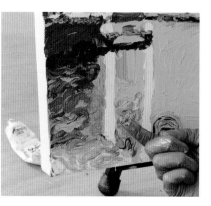

8 Once your finger is contaminated with Blue, swirl it into the yellows to the left of the car headlight shadows at the bottom left of the canvas.

9 Once your finger is contaminated with Yellow, swirl it into the dark purple to the right of the car headlight shadows.

10 Once your finger is contaminated with Blue, swirl it into the Orange/Pink/Purple just above the Orange in the bottom left corner of the canvas.

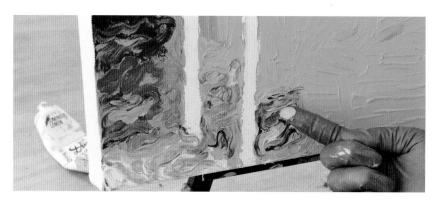

11 Once your finger is contaminated with Orange/Pink/Purple, swirl it back into the Purple/Yellow to the right of the headlight.

12 Once your finger is contaminated with Blue again, swirl it back into the Orange/Yellow at the bottom left of the canvas, near the area you swirled into in Step 9.

13 Clean your fingers and pick up Cadmium Yellow Hue. Place a chickpea-sized amount on your pointer fingertip and create long, feather-like horizontal strokes to the right of the car into the outline of the street. Go all the way up to the curve of the grass line on the right side and stop just after the headlight shadow on the left. This is the most therapeutic part of the painting for me, breaking up this green with other colors using a soft painterly stroke.

14 Clean your fingers and pick up Cobalt Blue Hue. Place a chickpea-sized amount on your pointer fingertip and swirl it into the light blue between the car headlight shadows, above the other colors you've swirled.

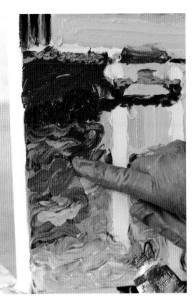

15 Once your finger is contaminated with blues, swirl that into the purples and pinks on the left.

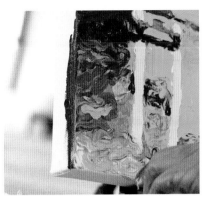

16 I'm taking time to deposit some Cobalt Blue on the side of my canvas so that I can pull this paint back into the canvas a few steps later. Add a strip of Luminous Opera behind the Cobalt Blue. Don't go all the way down to the bottom of the canvas with Luminous Opera—just with Cobalt Blue. This is going to create magnificent shadows.

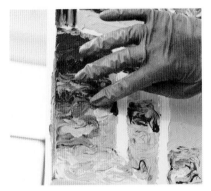

17 Continue adding more Cobalt Blue into the pink and orange to the left of the left headlight.

18 Using your pointer finger, pull both colors from Step 16 from the side of the canvas over into the existing colors, using a swirling, squiggly motion. Use a very light touch here. If nothing is happening, you need to add more paint to your fingers. We are creating that oil-in-a-puddle-on-a-rainy-day look across the road.

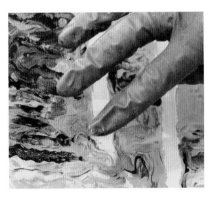

19 Clean your fingers and pick up Luminous Violet. Place a chickpea-sized amount on your pointer fingertip and swirl it into the bottom of the canvas to the left of the left headlight.

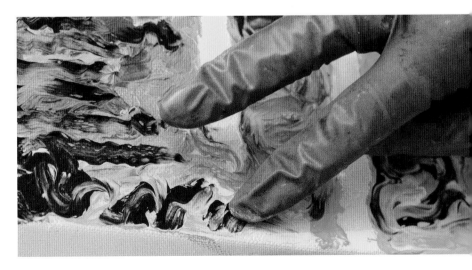

20 Clean your fingers and swirl more Luminous Violet into the Cobalt Blue at the top. Look for blocks of one color and break them up.

21 Once your finger is contaminated with Luminous Violet, swirl it into the upper space between the headlight shadows.

22 Clean your fingers and pick up Cadmium Yellow Hue. Place a chickpea-sized amount on your pointer fingertip and swirl into the Cobalt Blue from the previous step, and then into any existing light blue.

23 Clean your finger and add a few squiggles of Cadmium Yellow Hue to the right of the right headlight shadow, near the other group of swirled colors from earlier.

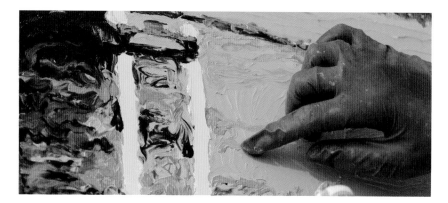

Finish the Road

1 Let's change gears and work with Luminous Opera. Clean your fingers and place a chickpea-sized amount on your pointer, middle, and ring fingertips. We are going to swirl strands of Luminous Opera into the Ice Green at the bottom of the painting, working from the bottom up. With all three fingers, create waves into the Ice Green, hugging the bottom edge. Use a very light touch and stay in the center of the Ice Green—this is the road.

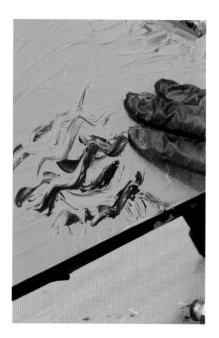 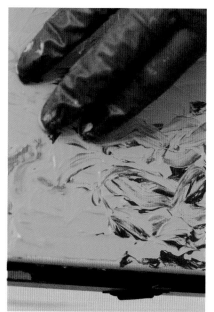

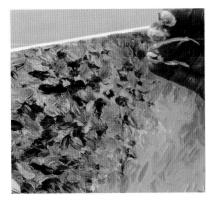

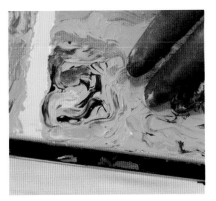

2 Clean your fingers and pick up Horizon Blue. Place a chickpea-sized amount on your pointer, middle, and ring fingers and repeat the pattern, working in the bottom-right part of the canvas to the right of the pink (Luminous Opera). Once it stops making color, stop swirling it in.

3 Now you have extra paint on your fingers, why not get rid of it in a good way by dabbing it into the trees? It's a great way to switch colors while utilizing a bit of leftovers from the previous color.

4 You'll have extra green from the tree leaves on your fingers, so bring that down to the left of the pink squiggly pattern and repeat the pattern.

5 Clean your fingers and pick up Cobalt Blue Hue. Apply the same squiggly pattern above the Pink. Keep touching the blue paint and moving through it until the color becomes a milder blue. Move the Cobalt Blue Hue around so that it's blended into the rest of the road. Tickle it out of the blob! Send waves through it.

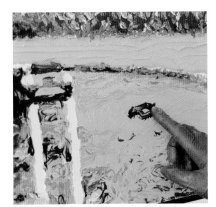

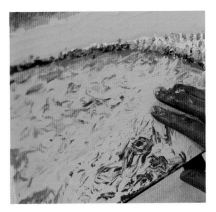

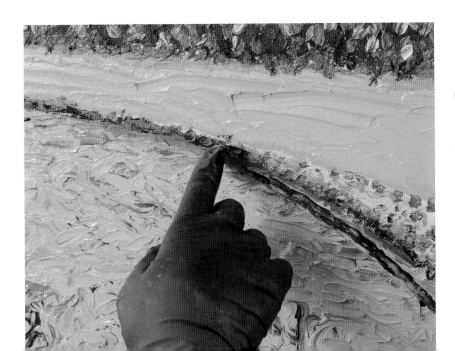

6 Clean your fingers and pick up Cobalt Blue Hue again. Place a chickpea-sized amount on your pointer fingertip and create a line, thicker to thinner in width, following the slope of the tree line, leaving a small space between the grass line. As the line gets closer to the car, it should become a jagged dotted line.

7 Clean your fingers and pick up Phthalo Green. Place a tint on your pointer fingertip and, starting at the left side of the canvas at the tree trunks moving right, create an up-and-down zigzag pattern until it fades. Clean your fingers and repeat, with a very light touch. As you continue down, press harder, and stop when the pattern is equal in length on both sides of the headlights.

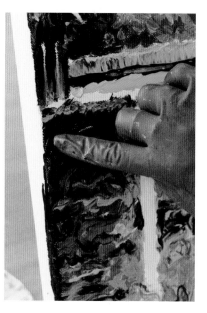

8 Clean your fingers and add another tint of Phthalo Green on your fingertip. Draw a horizontal line as straight as you can along the bottom of the zigzag pattern.

9 Clean your hands and pick up Cobalt Blue Hue from the canvas, next to the left headlight. Just touch it slightly, then bring it up to the green zigzag line and repeat with the Blue over the green zigzag, keeping the horizontal line below it pretty visible. Touch up with Green or Blue if you need to make either color more present. If the paint isn't going where you want it to go, use more paint with a lighter touch.

10 Clean your fingers and pick up Luminous Violet. Place a chickpea-sized amount on your pointer fingertip and apply a slightly squiggly thick line over the yellow line to the left of the left headlight.

Add Trunks and Branches

1 Let's do tree trunks now. Clean your fingers and pick up Cadmium Yellow Hue. Start on the far right side of the canvas and create a closely dotted line sloping down slightly to the right.

3 Clean your fingers and pick up Luminous Opera. Place a pea-sized amount on your pointer fingertip and apply this to the bases of the tree trunks, moving up into the middle of the grass. Dot your way up but stop about halfway. Make these dots thinner than you think they should be—they'll get thicker as you go on.

2 Continue down the line, moving to the left. The trunks should get closer together and thinner as you get further left. Create smaller "Y-shaped" branches into the leaves, too.

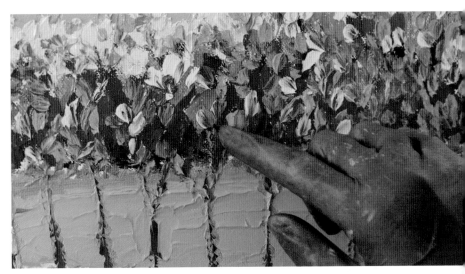

4 If you make one too thick, just clean your hands and push the Ice Green back into the pink/tree trunk.

5 Dot over the smaller Y-shaped branches with Luminous Opera while also extending them. Move top to bottom and from the bottom of the trees into the trunks. Create a few new branches from the trunks into the leaves as well. *Artist trick: branches are always thinner in real life than your brain assumes.*

6 Clean your fingers and pick up Luminous Violet. We're going to create the tree leaves with long dashes, using a very light touch. Place a pea-sized amount on your pointer fingertip and dab it into the trees in any area that's too yellow or monochromatic, cleaning your fingers and reloading paint as needed. Focus on the bottom half of the trees, avoiding applying the purple in the top half. Squinting your eyes helps here because it will blur your painting and defocus your attention. This allows a painter to see JUST the basic form and colors—allowing me to notice glaring errors.

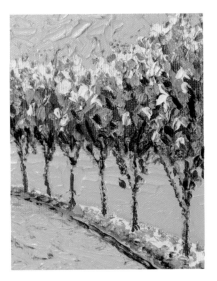

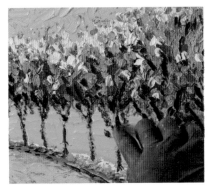

7 Create light dots along the right sides of the tree trunks (not the left) to create a shadow.

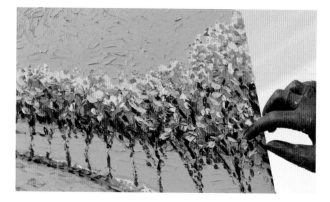

8 Clean your fingers and pick up Yellow Green. Place a chickpea-sized amount on your pointer fingertip and dab it through the leaves in a random pattern in different directions left and right, at angles. Stay away from moving up and down—that never looks good for leaves; we want to create a blowing effect. Place some horizontal leaves over the Y-shaped branches to give the effect that the tree canopy is coming down over the trunk—it will add some dimension.

Blur The Road

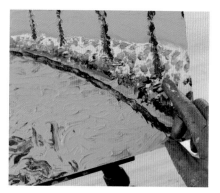

1 Clean your fingers and pick up Lavender. Place a chickpea-sized amount on your pointer fingertip and smash it into the Ice Green to the right of the right headlight. Make a general triangle shape in that nook.

2 Clean your fingers and pick up Luminous Violet. We're going to continue with the squiggly pattern in the Ice Green. Place a chickpea-sized amount on your pointer fingertip and apply in a snake-like squiggly pattern at the bottom of the canvas to the right of the right headlight shadow and to the left of the Luminous Opera (pink).

3 Clean your fingers and pick up Luminous Violet. Make small dabs at the bottom of the tree trunks in a random pattern.

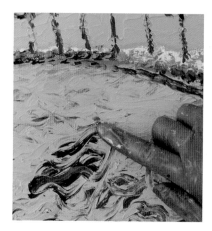

4 Clean your fingers and continue to apply Luminous Violet into the Ice Green space below the grass/tress around the pink (Luminous Opera).

5 Clean your fingers and pick up Cobalt Blue Hue. Place a chickpea-sized amount on your pointer fingertip and swirl into the Ice Green near the Luminous Violet from Step 4, moving up toward the grass line.

6 Now we're going to create clusters of leaves in the drain. Clean your fingers and pick up Cadmium Yellow Hue. You'll want to place a big blob on your pointer fingertip and smoosh it into the Ice Green at the bottom-right-hand corner in a snake-like motion. Follow the tree line up with the paint in a snake-like pattern into the corner edge. Ice Green and Cadmium Yellow Hue are such different shades of paint that it's easy to see the Cadmium Yellow on top of the Ice Green.

Finish the Car

1 My trees look a little flat. So I'm going to take a tint of dark green (Phthalo Green), and I'm going to dab in more horizontal leaves, concentrating toward the bottom of the trees. Don't be blocky or pattern-like; nature is fuzzy.

2 I'm also going to go over the windshield and the license plate of the car with Phthalo Green to make them more prominent.

3 Clean your fingers and draw a solid horizontal line underneath the license plate of the car with Phthalo Green. This will serve as the shadow of the underbelly of the car.

4 Clean your fingers and pick up Luminous Violet. Place a chickpea-sized amount on your pointer fingertip and, on the left side of the canvas, drag the purple down right next to the green tree trunks, moving left to right and stopping at the top of the car. Make them a bit smudgy. We need merely the sense of vertical lines here, not too neat. Clean your fingers and reload paint as needed.

5 Take this opportunity to dot some purple (Luminous Violet) horizontal lines into the trees. Create bars of dark, which will give the trees more depth.

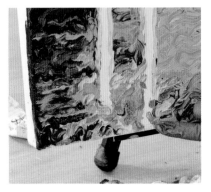

6 Clean your fingers and pick up Naples Yellow. With a light touch, run a thick vertical line along the right edge of the right headlight. Repeat on the right side of the left headlight. When you get toward the bottom, blur it out. Repeat on the other sides of each headlight.

7 Clean your fingers and pick up Luminous Orange. Place a chickpea-sized amount on your pointer fingertip and apply it in a snake-like squiggly pattern at the bottom of the section in between the headlight shadows. Add a small squiggle over the right headlight shadow as well.

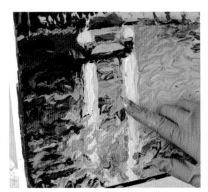

8 Clean your fingers really well. Pick up Titanium White and place a substantial amount on your pointer fingertip. Drop the White into the center of the headlight shadow and, with a very light touch, drag it down toward the bottom of the canvas in a mild zigzag pattern. Repeat on the other side.

9 Now we're going pick up Cadmium Yellow Hue and use it to break up the bars of the headlights. Place a chickpea-sized amount on your pointer fingertip and, beginning to the left of the left headlight, drag the Cadmium Yellow from the left of the headlight over the left headlight line. Repeat in a few places. Move inside the headlight space and back over the left headlight, touching the right one.

10 With the Cadmium Yellow Hue, outline the two headlights in a thick pattern. We just want to give the suggestion of an outline that goes all the way around the headlight.

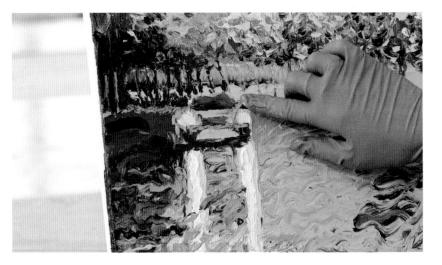

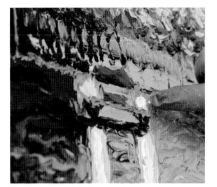

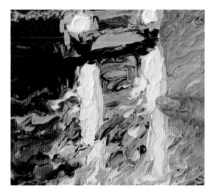

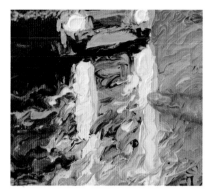

11 Clean your fingers and pick up Titanium White. Place a chickpea-sized amount on your pointer fingertip and dot right in the center of the yellow headlights, being careful you are placing the dot in the center and not on the outlines you just created in the previous step.

12 Clean your fingers and pick up Lemon Yellow. We're going to work inside the headlight shadow space. Place a chickpea-sized amount on your pointer fingertip and squiggle it into the left edge of the right headlight, coming over the headlight. Create several of these squiggles. Repeat on the left headlight, pushing the Lemon Yellow into the White.

13 Clean your fingers and pick up Cadmium Yellow Hue. Place a chickpea-sized amount on your pointer fingertip and streak into the left side of the canvas in the dark purple area.

Add Dimension

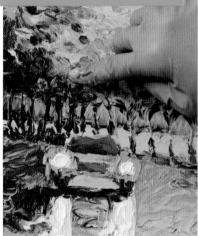

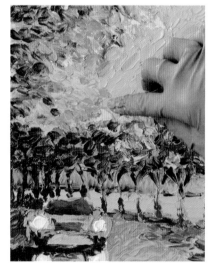

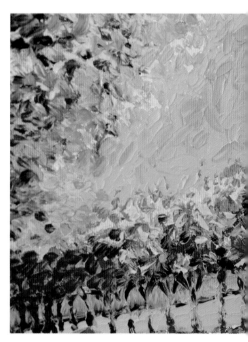

1 If the space in between your trees looks too triangular and flat, like mine does here (above left), highlight the underbelly of the trees with dabs of Luminous Violet. Remember: with finger painting it's always easier to go darker, but changing your mind and wishing it was lighter isn't as easy. It takes very little paint, such as Luminous Violet or Phthalo Green, to totally darken a painting. So bear that in mind.

2 Clean your fingers and pick up Luminous Orange. We're going to highlight the trees, so place a chickpea-sized amount on your pointer fingertip and make leaf-like strokes, concentrating on the left side of the canvas at the top of the trees. Clean your fingers and reload paint as needed.

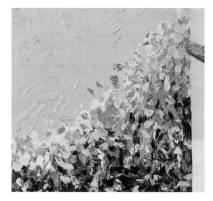

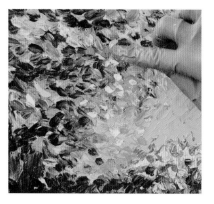

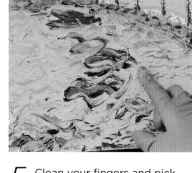

3 Clean your fingers and pick up Ice Green. Place a chickpea-sized amount on your pointer fingertip and dab it into the tops of the trees to give the illusion of sky peeking through the leaves and make them look bare at the top.

4 Clean your fingers and pick up Lemon Yellow. We're going to add some leaves to the trees on the left side of the canvas, coming into the Blue a bit on the edges of the trees. Avoid making a big triangle.

5 Clean your fingers and pick up Luminous Orange. We're going to create a reflection of the trees on the other side of the street by running the Cadmium in loose sketchy zigzags along the tree line, to the left of the existing orange squiggly lines. Place a chickpea-size amount on your pointer fingertip and apply it in a squiggly, feather-like pattern. Run it until it stops bringing in color, then clean your fingers and repeat.

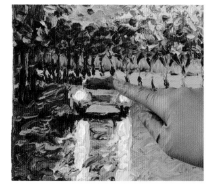

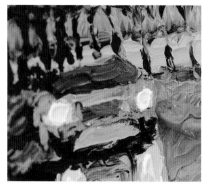

6 My windshield is a bit small in relation to the size of the headlights, so I'm going to push it out just a little with clean fingers, very lightly. Voila! That's how easy it is; finger painting is a lot about pulling and pushing paint that is already on the canvas itself. You can also push the headlights in a bit if yours are too big, like mine are here.

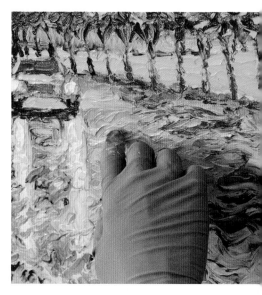

7 I'm also making the outlines of the car stronger by adding Ice Green along the left edge of the windshield. When you want something to show up, darken or lighten whatever is directly next to it—a classic artist's trick!

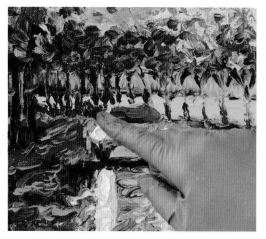

8 Clean your fingers and pick up Naples Yellow. Place a chickpea-sized amount on your pointer fingertip and apply light horizontal wispy movements to the right of the car. Pull these right into the purple and pink.

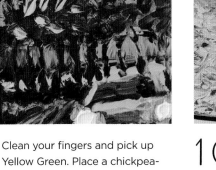

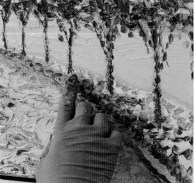

9 Clean your fingers and pick up Yellow Green. Place a chickpea-sized amount on your pointer fingertip and apply a few leaf-like strokes right over the purple trees in the back of the canvas, above the car.

10 My grass area looks too green to me. I'm going to apply Cadmium Yellow over the Green to lighten it up. I'm moving all the way up the grass line, cleaning my fingers when they get contaminated with Green and reloading paint. Adding lightness is always a bit more challenging because it requires a greater volume of light-colored paint in order to see the change.

11 Clean your fingers and pick up Lavender. We're going to work in the upper-right part of the road where it curves, using short, wavy, left-to-right horizontal strokes down the grass line but not hugging it completely. Work the Lavender into the other existing colors in the right area of the canvas.

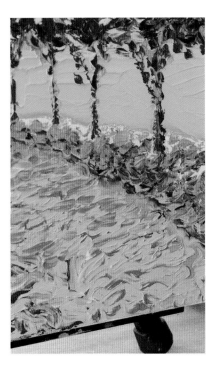

13 Let's solidify the tree trunks and give them more of a presence. Clean your fingers and pick up Luminous Violet. Place a pea-sized amount on your pointer fingertip and run a fluid line of small dashes down the tree trunks to the right of the tree (the shadow side). Add a few purple highlights to the smaller Y-shaped branches at the top, too. If you add too much paint, just clean your hand and give a little push from the Ice Green back into the trunk. Repeat on all of the trunks except those in the far distance (several on the left). While, yes, your fingers are thick and cannot draw fine lines, this strategy is your cheat for creating fine lines.

12 I'm also adding some dabs of Lavender into the grass area.

14 Clean your fingers and pick up Lavender. Place a chickpea-sized amount on your pointer fingertip and scribble in between the tree trunks over the Ice Green. Create darker Lavender Z patterns closer to the grass line at the bottom of the trees so that it's darker toward the edge of the grass line. Continue through all the trees.

Make the Finishing Touches

1 We're almost there! As in some of the other paintings, one of the last steps is adding falling leaves to suggest the illusion of depth, as if leaves are falling in front of the image. Clean your fingers and pick up Titanium White. The key to this step is not putting too much White down; a second key is to WAIT until the absolute end of your painting to do this. Place a pea-sized amount of White on your pointer fingertip and, moving left to right only (not up and down), swipe leaf-like strokes randomly throughout the painting—some in the street, some larger, some smaller, some clustered, but no patterns! Light touch! Think of it as if you're skipping stones from the right side of the painting to the left—the white strokes (leaves) get smaller as you move left. (Don't make them equidistant.) This will give the illusion of wind blowing the leaves right to left. Clean your fingers and reload paint each time you want to make a new dab. As long as you're using a light touch, you should be able to get about two swipes with each paint amount.
If you're left-handed, it'll likely be swipes in the opposite direction.

2 Once you're done laying down the White, clean your fingers and pick up Luminous Orange. Place a chickpea-sized amount on your pointer fingertip (we use a bit more paint here in order to cover the White fully) and push the Orange right over the top of each White leaf. The lighter, the better. Remember to relax and have fun! Use a little more Orange than White. But if a little White peeks through, don't try to redo it; just adjust your amount/technique on the next ones. I swipe right to left, but it's all about what you're comfortable with. Follow the stroke of the White; re-create the motion you used when you added this. If you have White showing through you need to use more Orange. Clean your fingers and reload each time you apply Orange. Leave a few white dabs—we're going to apply Yellow over a couple of these.

3 Using the same technique, cover any remaining white strokes with Lemon Yellow. I even swipe some over the Orange to create a dual-colored leaf (don't cover up all of the Orange).

4 If you put a leaf where you decide you don't like it, you can easily remove it. With clean fingers, swipe the sky into the leaf and remove the leaf paint using two fingers to swipe the color off. You can also make leaves skinnier by pushing the Blue into the leaves to condense their edges.

5 Once you're happy with your leaf placement, you're done! If you are going to frame your painting, you don't need to paint the edges. If you're not going to frame it, paint all four sides by following the general colors of the painting and continuing them to the sides of the canvas. Let your painting dry for 3–4 weeks.

ABOUT THE AUTHOR

Brooklyn-based artist Iris Scott has spearheaded the movement to oil paint without brushes. Iris sells her stunning original finger paintings worldwide and she is represented by galleries in multiple cities, including San Diego, Seattle, Jackson Hole, Denver, and San Francisco.

Iris Scott earned her BFA in Painting and her MA in Teaching. As an art student, she studied in Florence, Italy. She did not begin finger painting until 2010. Living on a shoestring in Taiwan at age 26, she discovered the advantages of painting with her fingertips over brushes after a bout of "lucky laziness." Unwilling to pause her painting to clean her brushes, Iris found that manipulating thick paint with fingertips offered advantages over the bristles of a brush. She has not picked up paintbrushes since.

Iris' advancement of finger painting has forever changed our perception toward this colorful and tactile technique. Her paintings have garnered attention from press worldwide, including the *San Francisco Globe*, *Colossal*, and *American Art Collector* magazine. Her most iconic painting, *Shakin' Off the Blues*, has gone viral several times, including on Reddit, where it captured nearly 1.5 million views. Iris has blazed a unique trail in the art world, and is enthusiastic about sharing her artistic secrets with tens of thousands of Facebook and Instagram fans. She is not interested in keeping her finger-painting strategies secret because she wants to spread the joy of this medium. Browse her constantly expanding portfolio of artwork and videos at www.IrisScottFineArt.com.